Landscape Painting
Step-by-Step

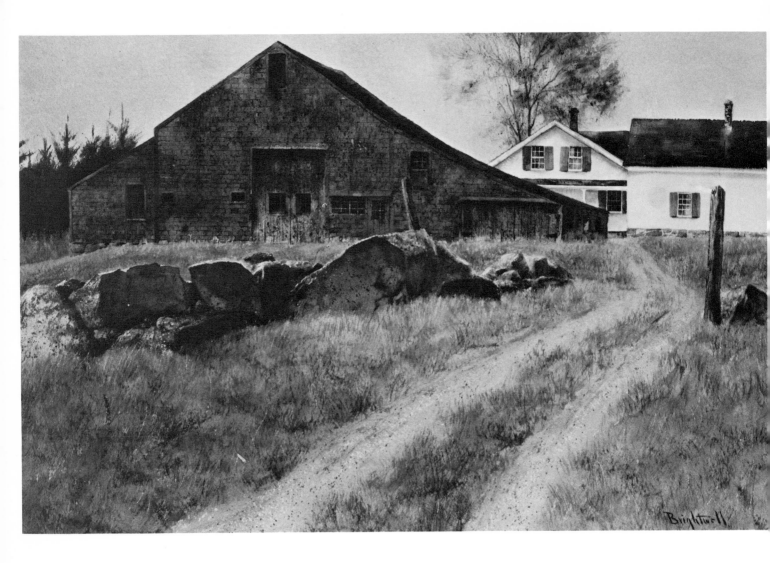

THE SURVIVOR by Walter Brightwell, watercolor.

The viewer's eye enters the picture at the lower edge and travels along the road to the focal point of the painting, where not only the road, but the slant of the old barn's diagonal rooftop, the receding rock formation, and the lines of the white house all meet. The tree rises from the center of interest like a flag and the viewer's eye is kept from moving out of the picture by the dark post, on the right hand side, which aligns with the chimney directly above. It is a simple, effective pictorial design. (Photograph courtesy American Artist)

A revised and enlarged edition of The Art of Landscape Painting

Landscape Painting Step-by-Step

BY LEONARD RICHMOND

WATSON-GUPTILL PUBLICATIONS / NEW YORK

Published 1969 by Watson-Guptill Publications, New York, New York
All rights reserved. No portion of the contents of this book
may be reproduced without written permission of the publishers.
Published by special arrangement with Sir Isaac Pitman & Sons,
Ltd., London, whose *The Art of Landscape Painting*, © Executors
of the late Leonard Richmond, 1958, furnished the basic text
for this volume.

Composed in eleven point Electra by
Harry Sweetman Typesetting Corp.
Printed and bound by The Hadden Craftsmen, Inc.
Designed by Robert Fillie

Library of Congress Catalog Card Number: 77-82747.
Manufactured in U.S.A.

Introduction

This book is intended to be a guide for students who are desirous of taking up landscape painting. The average art student, fresh from the schools, is oftentimes concerned at the difficulties connected with the manifold aspects of nature. This book, then, is primarily intended to be a solid help, so that the student can tackle anything and everything without any fear of wasting time unnecessarily. The author has suffered personally by having his thoughts turned in many directions and trying all sorts of experiments, the majority of which were quite unnecessary, and he feels that the whole of this book, if carefully read, will save thousands of pitfalls for the beginner. There is only one thing which is really of every importance for the would-be landscape painter, and that is to cast away all feeling of timidity. Nature is so overwhelming, and she has so much to say, that to the beginner she seems to be chattering incessantly. It is up to the student, when making a sketch, to ignore everything except one motive. The great charm of landscape painting consists in the fact that it is full of possibilities for self-expression. The portrait painter, to a certain extent, has a more limited field.

Art is changing today. Gone forever are those days when merely a copy of nature was sufficient for the artist. There is no earthly reason why an art student should not have a black sky and vermilion trees in a landscape if he or she feels so inclined. Yet I would advise a student, in the initial stages of sketching out of doors, to stick to actual facts, until his mind becomes an encyclopedia of knowledge, based on natural form, color, and tone. Invention follows when knowledge leads the way.

My experience in the past, as a teacher of landscape painting, has been that quite ninety percent of students, in their earlier days of sketching out of doors, invariably try to put in all they see. They are too conscientious. This endeavor to portray everything they see out of doors defeats its own purpose.

What is to be done? Simplification is the only thing that matters for the beginner, and sometimes simplification is the only thing that matters for the advanced painter. Avoid hero worship of other people's paintings. A cool appreciation of Turner is better than a fevered adulation. Remember your own individuality is just as important to you as their's was to the great men and women of the past. Elimination of detail in sketches and finished pictures explains their meaning in a much clearer manner than overstatement. To make a sketch in color of a tree, paint the tree, not the leaves, except the few that may be noticeable on the edges of the general silhouette form. Later on, experience gives suggestions of detail without breaking up the unity of tone.

To attain to the status of a practical workman is essential to the landscape painter. The brush, when charged with color, must obey the mind. Always use a paintbrush with a clear understanding of its flexibility. It is ludicrous to see a painter use a paintbrush like a lead pencil, thus missing the chance of letting the brush function naturally. Whatever medium the student happens to use for sketching, it is a good thing to bear in mind that strength in his painting, for the first few years at all events, is more desirable than delicacy. Delicacy rarely leads to strength, and is often effeminate; but a painter who is successful in strong handling, rich coloring, and striking pattern, is generally very interesting when tackling subjects of delicate tints.

L. R.

Contents

Color Plates

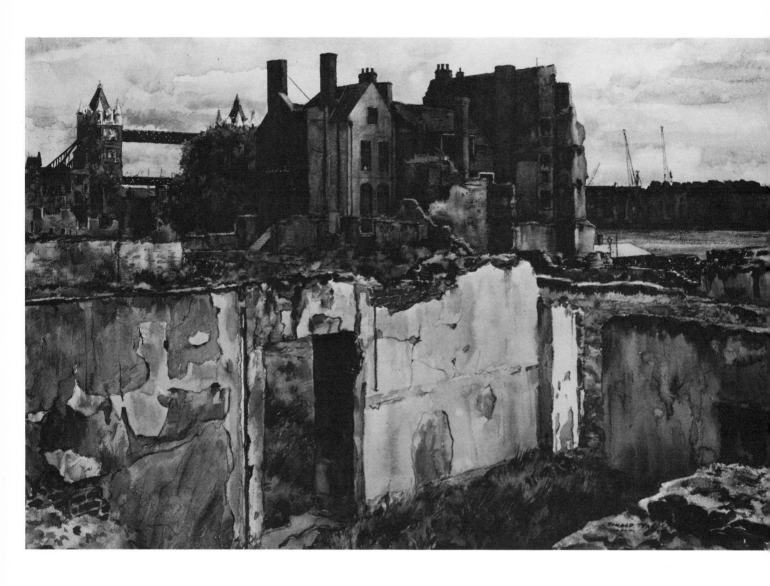

TOWER BRIDGE by Donald Teague, watercolor, 18¾" x 27¾".

Painting cityscapes often becomes difficult because of the extreme clutter of architectural elements. Here the artist has organized his composition into three distinct planes to minimize this kind of confusion. The foreground is an extreme, detailed close up of a ruined wall, with careful rendering of the broken surface. Looming above this, in the middle ground, is a dark central cluster of buildings, in contrast to the lighted ruin in the foreground. And in the distance, the viewer sees the bridge silhouetted against the sky and the strip of buildings on the far shore, in shadow. The secret of the painting's success is really the decision to devote half the picture to the extreme closeup of the wrecked wall, with its intricate textural detail. (Courtesy Virginia Museum of Fine Arts, Richmond, Virginia)

A Fresh Look at Landscape

S peaking of a landscape picture, one presupposes that the picture contains within its boundaries a foreground, middle distance, distance, and sky; but landscape art includes more than this in its outlook towards nature.

ARCHITECTURE

Although buildings may not be described as nature's children, yet architectural subjects, whether fine buildings or cottages, form a very important branch of landscape painting. It matters little how modern buildings may be. As soon as they are erected and stand in company with nature's moods, they become part of the general effect. The glow of light from the sky will cast its mantle of beauty over the crudest structures that have been built. Nature has a good way of balancing things up by leaving the impress of herself on surrounding objects. An iron bridge of hideous design is capable of reflecting beautiful color from the river below. Likewise, a similar bridge, if entirely neglected by man, will show bronze and orange tints and other colors caused through rust, etc.

It is a mistake to imagine that modern architecture is of no landscape value. Those who have been privileged to see the skyscrapers of New York, and particularly the view from the district of Brooklyn Bridge, know otherwise. Such massive dignity of ever-rising heights, connecting up to the sky from the earth below, gives fine opportunities to the landscape artist. The wonderful illumination at night on the buildings in New York, the source of which is mostly disguised, is a revelation to the artistic mind. At the close of day, when the sun has set, and with still a glow left in the sky caused by the afterglow of the sun, these skyscrapers have shown marvelous color, and, nearly all detail being eliminated, their massive proportions looked even greater than when exposed to sunlight.

SHIPS, TRAINS,
AUTOMOBILES,
INDUSTRY

When one speaks of landscape, the sea is invariably included, paradoxical though it may sound. Travel posters today take artistic advantage of those magnificent liners crossing the Atlantic and Pacific Oceans. Watching one

of these large, but beautifully designed boats coming slowly into harbor, with such unconscious grace and charm, awakes an esthetic thrill in the soul of an artist. Then there is the modern locomotive plying on the railways. Thanks partly to the great boilers needed to cope with the necessary speed on the express routes, the design of the engine today is genuinely beautiful and good to look upon. Then there are automobiles. Certain types of automobiles may be described as first cousins to the locomotive for artistic form.

There have been pictures painted with a weird and beautiful light thrown by the headlights of a car on the roads and adjoining trees. The results have been fantastical and quite original. Modern invention is always capable of giving fresh ideas to a landscape artist.

One has only to think again of the great steel yards, dock yards, shipping yards, etc., to realize what a success certain artists have made of these subjects. Some of the finest lithographs ever executed were done by Joseph Pennell of the huge works and cranes, engineers and men, who were engaged during the construction of the Panama Canal.

There is a good deal of ugly beauty in industrial subjects. With blast furnaces working, the glare is easily seen at night, and the adjoining slag heaps often taking on sinister forms. Then we have canals, with the attendant low-lying barges; cathedrals, churches, public buildings, mountains, lakes, famous cliffs and caves, barns and farmhouses, villages, inns, rivers, quick-running streams, many types of trees, cattle, and other items.

It should be understood that the outlook for the landscape painter is very big and comprehensive. The elements of a landscape being of so wide a range, the student will do well to remember that the years fly along so quickly for the serious landscape artist that there is an urgent necessity for continuous work, both in and out of doors, not neglecting to sketch out of doors in the winter sometimes, if the weather is suitable.

PAINTING UNPROMISING SUBJECTS

Some modern artists have successfully translated the most unpromising subjects. This requires intelligence of no mean order. It is not easy to select a subject of a hard iron railing, one or two flower pots, a trash can, and stray articles, and create something fine and big in pictorial language. It is comparatively easy to create charm and delicacy by painting a picture of honeysuckle, violets, or any other flowers in a garden. The mentality of people today is on a more interesting plane, certainly on a much higher plane, where pictorial art is concerned. Triviality is not asked for—nor necessary. There is as much difference between a picture of intelligence and thought and a picture of a little robin redbreast on the snow, as there is between a good book and the sweet, nauseous short story in the cheap magazine.

Many artists apparently must go to well known places, where they are sure there is something charming and something—we might almost say pretty. Wherever an artist happens to be, whether on the top of a mountain, in the courtyard of slum tenements, or any other place on this earth where there is light and air, that artist should be capable of finding something of interest to paint. Many painters have felt insulted when visitors to their studios have quite innocently said of a picture, "Oh, how pretty!" That is severe condemnation for the unfortunate painter—not praise.

It is difficult to imagine Shakespeare, with his mentality, if he had been a

pictorial landscape painter, producing pretty, meaningless pictures. Certainly it would be very difficult to imagine Ibsen producing sweetly dull landscapes.

The problem of color in pictures is difficult. Certain subjects demand a quiet, restrained color scheme, while other subjects insist on a sumptuous color effect. Glowing colors sometimes explain too much in a landscape, whereas restrained colors do not always tell their message at one glance, and, indeed, suggest sometimes mysterious reserve, which helps to arouse one's curiosity. All these and other problems are for each person to settle individually. Bright colors in most media can unquestionably become dull when the hand of time takes a part in their destiny.

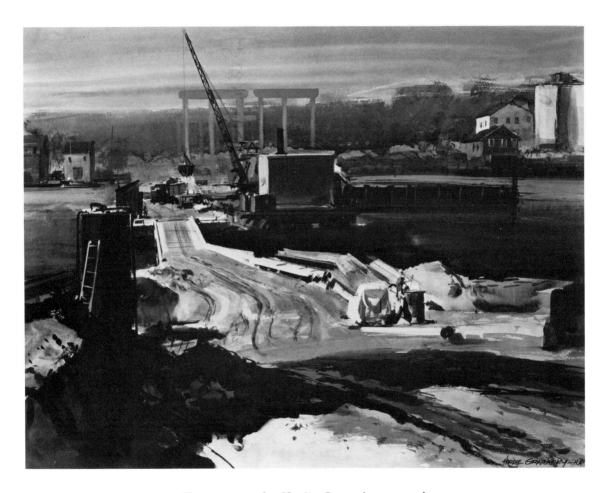

THROUGHWAY by Hardie Gramatky, watercolor.

Industrial subjects are not normally thought of as landscapes, but they often make striking landscape subjects. This study of the construction of a highway makes particularly interesting use of light and atmosphere. The viewer's eye follows the lighted roadway back into the distance and the intensity of the light is strengthened by the splash of dark shadow that cuts across the foreground. Beyond the focal point of the painting, where the actual construction work is going on, the landscape melts into a grayish haze, with few contrasts of light and shadow—no strong darks and no distinct lights, except for the buildings on the extreme right, across the river, which catch a flash of sunlight and thereby balance the action in the center of the picture. (Photograph courtesy American Artist)

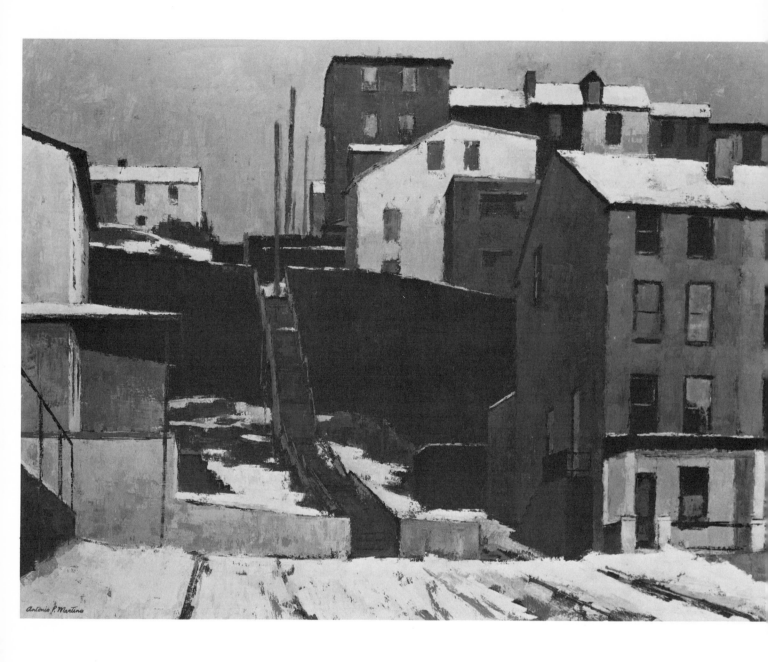

HILLSIDE HOUSES by Antonio P. Martino, oil.

The surfaces of old buildings give the painter an interesting opportunity to experiment with the textures of paint. This artist has rendered the crusty surface of the snow and the weathered walls of the buildings as patches of broken color. Broken color effects, as distinct from flat color, are achieved by painting one tone into another, using either a brush or a knife, and carefully avoiding the temptation to blend the wet paint. The strokes are simply put down and allowed to stand, thus retaining the vitality of the artist's touch. (Photograph courtesy American Artist)

The Plan of a Picture

A picture which was not planned originally by the painter might be compared with a house that was built without any previous consideration being given to its style of architecture, or without any consideration as to whether it is suitable for utilitarian purposes. Such a house, through the want of definite thought on the part of the builder, might prove interesting as a freak dwelling, but the chances are very remote that it would be suitable to live in, and the lack of cohesion in design would give no rest to the mind of its tenants.

IMPORTANCE OF PLANNING

It is obvious that every picture, whether good or bad, has some sort of arrangement or design behind it, which was originally planned by the artist. The plan of a picture can make or mar the final result of the painting. Therefore, too much stress cannot be laid on the supreme importance of this branch of landscape art. It is of genuine advantage to the student to take the subject up in the early stages of training for landscape art. Development in painting follows naturally, and in some instances quite quickly, if the student facilitates his future progress by acquiring the habit of good picture designing.

The pictures of old masters of landscape art are living examples of fine compositions, displaying adroit skill in the spacing of their pictures. Students should become so soaked in the science of picture planning that eventually they will subconsciously do the right thing for each sketch or picture, in much the same way that we are rarely conscious of breathing for the purpose of keeping the body alive.

DOMINANT SUBJECT

The subject of a picture must be master of the whole scheme of design. If the main subject happens to be a bridge over a stream, everything in that picture, whether in color, tone, or drawing, must result in making the bridge pre-eminent in the final result.

There are many interesting tidbits of nature, and it is quite easy to wander

away from the main theme when sketching the landscape, so it becomes a matter of self-control or self-discipline when one is tackling a complicated subject.

A picture must have something to say. It can speak more eloquently when planned with judicious spacing. Too many elements in one landscape cause confusion in the mind of the spectator. It is like several people all speaking together, such a lot of noise that nothing can be clearly heard or understood. Many good pictures do not need a catalogue to give you the title. It is already self-evident in the clever manner in which they have been treated by the artist.

MAKING
SUBORDINATE
ELEMENTS
INTERESTING

After the student has acquired the necessary skill in placing the primary interest of the picture right across the mind of the spectator, the next thing to learn will be to make all the subordinate portions of the painting really interesting, each in its own compartment, yet without interfering with the unity of the whole picture.

To attain this purpose, it is admirable practice to design little drawings and color sketches indoors. The result is sometimes amusing, but it is always interesting to try some creative work, and, moreover, the winter evenings can be profitably used for this type of drawing and painting, as daylight is not necessary for invention experiments. To make designs away from nature leaves the mind in peace to function naturally, so that designs invented at home can at least display more intelligent spacing than is generally possible when the artist has to overcome several difficulties out of doors.

MAKING SMALL
EXPERIMENTAL
COMPOSITIONS

It is a good plan to have definite titles to work from, such as: The Storm, Tranquillity, The Bridge, Sunrise, Moonlight, Evening, etc. There are scores of subjects for the artist, waiting to be selected, and which are appropriate for landscape art. Miniature sketches about 2" x 3" are quite large enough for experimental compositions. It is far easier to see the effect and design of a little sketch than it is to grasp the meaning of a larger painting or drawing. That is why so many artists rule squares all over the face of a sketch, with a corresponding number of squares ruled on the larger picture, so that they can faithfully copy the original subject from the sketch by using the exact proportions seen in the smaller picture.

The more indoor creative sketches the student makes, the more fit that student will be to select proper subjects from nature. The eye becomes trained to see good pictorial subjects, and to select that point of view out of doors which is all-important for the correct spacing of the subject on canvas or paper.

Pastel is a splendid medium for indoor inventive sketches, if used on a fairly dark paper, warm gray or brown for preference. Soft pastel is best for this purpose, and the tinted paper should have a fairly smooth surface, so that the pastel can glide quickly and easily over the paper. Mistakes are easily altered by rubbing the pastel off with a wad of cotton or a bristle brush. When using pastel for little landscape designs, it is better for this medium not to work on a scale smaller than 4" x 3".

Apart from pastel, it is also good practice, in doing these small sketches, to suggest the subject rapidly with a lead pencil; then, with a small watercolor

paint brush, say No. 3, use brown, green, or black ink and indicate by line, or mass, or both, the subject that you wish to portray. Pencil is sometimes insufficient to suggest the weight and bigness of a design, even though that design may be only 1″ square. As soon as the brush is used in addition to the pencil, the design becomes manifest and explains the intention of the one who designed it. It is also good practice, in making small, inventive sketches, to draw your sketch lightly in pencil, outline it in brown or some other colored ink with a brush, and then tint it with ordinary watercolors. (See Plates XXXIII and XXIV.) The charm of adding color to a design fascinates the would-be artist, and usually results in an increase of work.

The student must work, if possible, at least six days a week. Yet work is of no value if the student is tired. Good physical health is an asset for good results. No landscape painter of normal health should ever suffer. Two thirds, or even six months, of the year spent out of doors usually provides the necessary store of health required for the remaining portion of the year spent indoors.

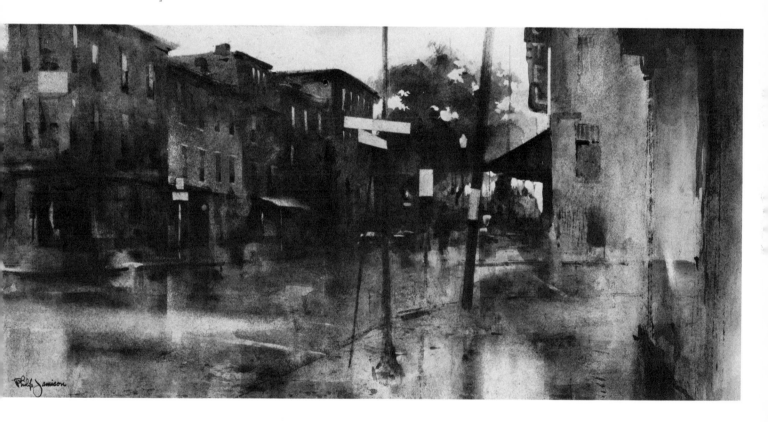

MARKET STREET WEST by Philip Jamison, watercolor.

Rain is a particularly difficult subject to paint because a gray, rainy day tends to minimize contrasts of light and shade, and form tends to disappear. In this cityscape, painted on a rainy day, the artist has not made any attempt to paint the falling rain itself, but has simply painted the reflections on the wet street and buildings. The wetness lends a fascinating luminosity to the street, wihch breaks up into interesting patterns of dark and light, with reflections from the buildings above. The wet walls and windows of the buildings, too, pick up touches of reflected light. (Photograph courtesy American Artist)

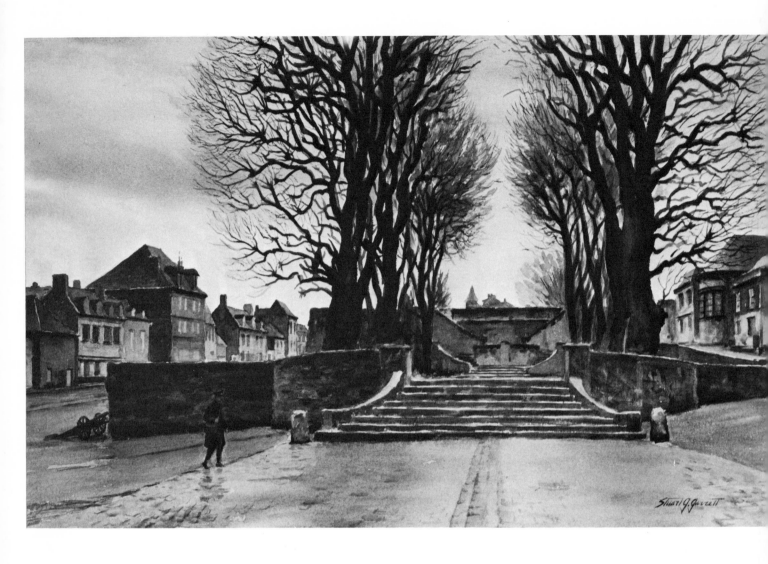

Facteur by Stuart Garrett, watercolor.

A symmetrical subject always runs the risk of being monotonous. The artist has avoided this problem by shifting his subject slightly off center to the viewer's right, so that a glimpse of townscape appears to the left. Thus, the center of interest appears not in the middle of the picture, but one third in from the right hand side. This landscape is a particularly strong use of perspective, with all elements leading the viewer's eye to the vanishing point at the head of the stairs. Yet any effect of rigidity is avoided by the sinuous shapes of the trees, which lend a delicate rhythm to a composition which would otherwise seem barren. (Photograph courtesy American Artist)

Elementary Compositional Exercises

In Chapters 3 and 4 on compositional exercises, the whole secret of landscape designing from a pictorial standpoint is fully explained. Students who wish to be proficient in composition should start straight away. Knowledge gained indoors is vastly useful for outdoor painting.

PLACING
HORIZON LINE

To start, then, from the very beginning, one of the first things to avoid in a landscape is the unfortunate effect of making the sky occupy half the area space of the picture. Fig. 1 shows the monotony of such spacing. In Fig. 2, the horizon is placed about one quarter of the distance up from the bottom line of the picture, with the sky occupying the remaining three quarters of the area space. This creates a more interesting ratio between the earth and sky. It is also possible to raise the horizon about two thirds or three quarters of the distance up from the lower line of the picture, with the sky occupying the remaining area space. This lends itself to an agreeable foundation for picture planning.

INTRODUCING CURVES

The next step in composition is the introduction of curves instead of horizontal lines. Under all circumstances and conditions, nature will insist on balance. For instance, in Fig. 3, the larger curve extending across the picture is balanced by the smaller curve on the right. Two similar curves are repeated above the two lower curves so as to create the illusion of distant hills, as demonstrated in Fig. 4; the only difference is that the smaller curve resting above is placed on the left instead of the right side. Simple as these curves are in this sketch, they already suggest a landscape in which the balance is evenly distributed. Students are advised to make several designs of swinging intersecting curves, keeping the less circular curves in the higher portions of the picture. There is a good deal of room for invention, even in the restricted area of curves, without the assistance of straight lines.

COMPOSING WITH
STRAIGHT LINES

In Fig. 5, instead of having curves with which to plan the pattern, straight lines only were used. As in Fig. 2, the horizon is placed somewhat low down

in the picture. The larger triangular hill spreading across the picture, which is balanced by the smaller hill, is similar in direction to the two intersecting curves in Fig. 3.

In Fig. 6, the same procedure is adopted as in Fig. 4, with the added advantage of a foreground. This little picture has quite a pictorial value. The converging lines in the foreground, spreading towards the hills, create a sense of distance, and the dark tone of the nearest hills helps to give a feeling of solidity, and almost a sensation as though they were covered with nature's own shadow. The two farther hills suggest the illusion of being in sunlight, since they are opposed to the solid and dark hills in front.

The student who is keen on invention could, by using Fig. 6 as a starting point for further progress, introduce groups of trees or intersecting fields on the side of the hills; or minute cottages, to accentuate the scale of the hills; or cloudlets in the sky; and might indeed continue for hours developing ideas, none of which is wasted when it comes to the actual sketching out of doors.

Fig. 1. Monotonous spacing.

Fig. 2. More interesting spacing.

Fig. 3. Balanced curves.

Fig. 4. Curves become hills.

Fig. 5. Pattern of straight lines.

Fig. 6. Straight lines become landscape.

MONOTONY,
CONTRAST,
AND ASYMMETRY

The next group of sketches, Figs. 7-10, consist of various arrangements of trees. In Fig. 7, two trees are placed on either side of the picture. This does not make a pleasant design, the chief fault being lack of contrast; but by taking one tree out of the picture, say from the right, the contrast now gained by two versus one, adds a little more sparkle to an otherwise monotoous effect. The result is shown in Fig. 8. An even better contrast is gained by placing another tree in the group on the left, thus giving additional strength to this group when compared with the one tree, as seen in Fig. 9.

Still further interesting results can be obtained by arranging what might aptly be described as the "inward composition." To do this in Fig. 10, for example, the nearest tree is left in the foreground, while the other trees are placed at various intervals, each one receding farther from the foreground tree. In this sketch not only do we get the contrast as demonstrated in the previous sketch, but there is an additional interest caused by the fact that no two trees are of the same height or the same distance from the spectator.

Fig. 7. *Symmetrical design lacks contrast.*

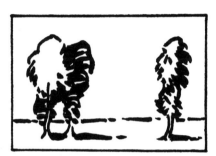

Fig. 8. *Asymmetry adds contrast.*

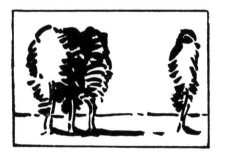

Fig. 9. *Greater contrast adds strength.*

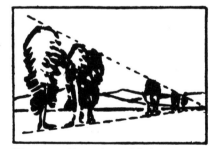

Fig. 10. *Recession adds interest.*

A NOTE ON
PERSPECTIVE

It is taken for granted that the student of landscape art has some knowledge of elementary perspective. If not, some lessons in perspective are advisable, particularly that section relating to buildings and reflections on water. There is no need to go through an advanced course in this subject. Personally, I think observation, backed by a few lessons, is quite sufficient. My own experience has been that observation is far more important than any scientific or academic training in perspective, though this may not apply to every individual. A picture can be spoiled by too close an adherence to the rigid laws of perspective. Some modern painters almost ignore its existence.

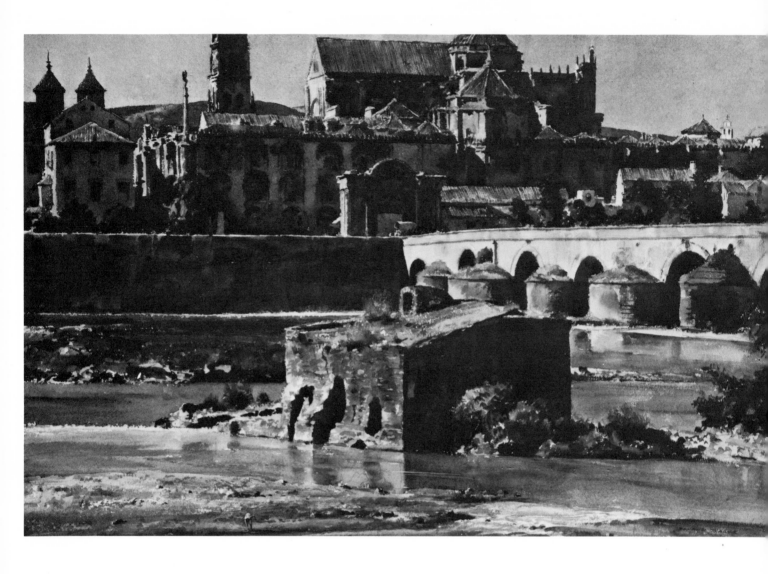

Córdoba by Donald Teague, watercolor.

The beginning painter should remember that buildings are simply geometric forms and must be visualized as one visualizes blocks and cylinders. Because the light enters this painting at a low angle from the left, the artist is able to model his forms quite simply: all the planes that face left receive the light, while the forms that face the viewer are in shadow. Having established this simple division of light and shadow, the artist is then free to render the intricate textures that appear within the shadows. Observe how the forms at the base of the bridge are rendered as cylinders, with the light and shadow subtly gradated around them. The artist has reduced the possible confusion of the architectural detail by placing most of the cityscape in shadow and highlighting only the critical architectural elements. (Photograph courtesy American Artist)

Advanced Compositional Exercises

In this chapter are some advanced exercises which owe their origin entirely to invention.

INVENTING
COMPOSITIONS

Figs. 11 and 12 show a skeleton groundwork of straight lines. Figs. 13-16 below explain their origin by the skeleton plans above. When drawing the original straight lines, I had no preconceived ideas as to what the ultimate result might be. First of all, it was exceedingly interesting to design three solid roofs in the Fig. 13. After completing this with colored ink, I drew parallel vertical lines to make the building solid in tone. When these vertical lines were completed, giving a halftone value, I added windows and doors. The next idea was to have an entrance into the picture, so a pathway was drawn leading towards the building. For the sake of pictorial contrast, I then drew horizontal parallel lines or curves to suggest the flatness of the ground, with two curves on each side and behind the building so as to suggest distance. The clouds are very simple—merely a direct outline.

Fig. 15 is precisely the same subject as the one above, but instead of a solid roof, the solidity of the colored ink was used entirely for the sky, leaving the cloud white. The experiment of adding a shadow partly on the face of the building, instead of on the whole frontage, and also leaving some of the fore-ground in sunlight, made the subject far more interesting. There is a certain feeling of pictorial comfort in Fig. 15. This is partly accounted for since light always looks well on a dark surface, instead of a dark surface being silhouetted on a light background. The darkness of the sky instinctively supports the cottage. In Fig. 13 above, the cottage appears to a certain extent to be isolated from the distance. In Fig. 15, by judicious arrangement of shadows, the cottage belongs more to the surroundings in which it is placed.

Fig. 14, based on Fig. 12 suggests a ruined castle or some building of antiquity which has long been in disuse. Here, again, the sky is dark and solid. The feeling of light on the building is due to the fact that there is no shading whatsoever on its surface. There is a certain amount of movement

in the foreground, caused by curved lines and unintentional or accidental handling, which helps to make the subject more interesting. The Fig. 16 sketch is also based on the top skeleton plan in Fig. 12 above. In Fig. 16, instead of buildings, the idea of trees is suggested, still keeping the geometric form of the original straight line drawing in Fig. 12.

It is not for one moment suggested that this a high form of art, but what it does do, in ninety-nine cases out of a hundred, is to stimulate interest in invention.

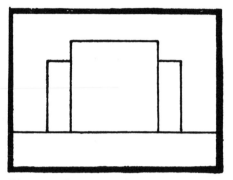

Fig. 11. *Symmetrical geometric skeleton.*

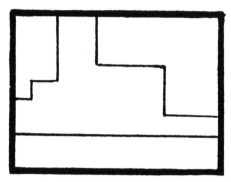

Fig. 12. *Asymmetrical geometric skeleton.*

Fig. 13. *Architectural scheme based on Fig. 11.*

Fig. 14. *Architectural scheme based on Fig. 12.*

Fig. 15. *Another variation based on Fig. 11.*

Fig. 16. *Landscape based on Fig. 12.*

It is really astonishing what an extraordinary number of variations can be based on one simple geometric plan. There does not appear to be any limit to invention, If a student designs a thousand geometric plans by merely using straight lines enclosed in a rectangular framework, that student would have no difficulty in getting three designs on each of those thousand geometric bases. Obviously, this would give three thousand inventions based on geometric form. There is no reason why half a million could not be designed, if such a thing were physically possible, and still fresh thoughts would arise in a never-ending procession.

DESIGNING WITH STRAIGHT LINES

Figs. 17 and 18 are designs based on straight lines. The motif of these two pictures was the Canadian Rocky Mountains. It was difficult to resist the feeling of curvature in addition to straight lines. Any curvature which may be discovered in these two sketches is caused by the inability of the artist to draw straight lines without a ruling pen; but, fundamentally speaking, it is all based on rigid lines. It is quite entertaining to design pictures with this limitation. The student who may be rather weak in composition would find invention on straight lines not only a good tonic, but a good stimulant towards creating more powerful results.

Fig. 17. *Straight line design based on mountain subject.*

Fig. 18. *Another mountainous straight line design.*

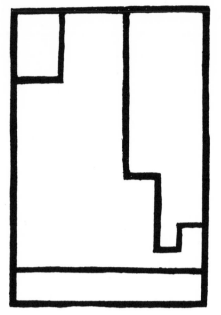

Fig. 19. *Geometric skeleton for vertical composition.*

Fig. 20. *Landscape design based on Fig. 19.*

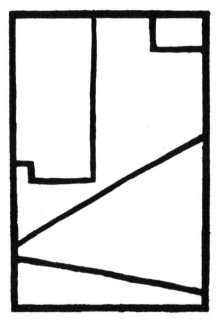

Fig. 21. *Skeleton of verticals, horizontals, diagonals.*

Fig. 22. *Composition based on Fig. 21.*

Figs. 19-22 are based on straight lines, but instead of having horizontal pictures, we now have the upright or vertical design. Again there was no premeditation when these lines were drawn as to what the result might be. It is not necessary to explain Figs. 19-22. They should now explain themselves quite clearly to the intelligent student.

Figs. 23 and 24, representing circular construction, give the plans of the pictures below, and the lower drawings (Figs. 25-28) demonstrate the vagaries of an artist. There is a feeling of excitement in drawing designs where practically every portion of the composition is based on curves. Here, again, there is no limit to invention. As in the previous examples, the artist had no advance knowledge as to what the results of the formal planning of these drawings would lead to. Had space permitted, at least fifty different results could have been shown from each of the two skeleton plans, but it is obvious that the four examples given are quite sufficient to encourage others to make their own experiments, and to do something where their own mentality is more important than any outside influence or environment.

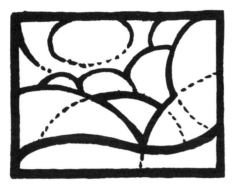

Fig. 23. *Compositional skeleton based on curves.*

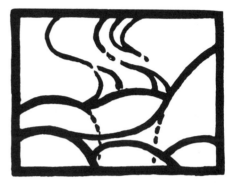

Fig. 24. *Another compositional skeleton based on curves.*

Fig. 25. *Landscape design based on Fig. 23.*

Fig. 26. *Landscape design based on Fig. 24.*

Fig. 27. *Another landscape design based on Fig. 23.*

Fig. 28. *Another landscape design based on Fig. 24.*

27

Fig. 29. Compositional skeleton with circular movement.

Fig. 30. Landscape design based on Fig. 29.

Figs. 29 and 30 are two more examples of circular movement in design. These also are self-explanatory. The suggestion of trees in Fig. 30 counteracts, by reason of their vertical shapes, the otherwise overwhelming number of curves. In Fig. 31, there is a circular formation, inside of which is spaced a whole group of trees. As the trees recede farther away towards the right, they are, according to the arbitration of this design, much smaller in height.

EXPERIMENTING WITH TREE FORMS The last drawing in this chapter (Fig. 32) consists of a rectangular form in which trees are placed, showing the pattern caused by the interstices of light between the branches and foliage. Quite a number of designs of this sort can be made by students without ever worrying as to the nature, origin, or species of the trees that they may invent for their own pleasure. A separate sketchbook can be used for making serious studies of the many varied types of trees in nature, irrespective of pattern planning.

Fig. 31. Circular form suggests recession.

Fig. 32. Composition of tree forms.

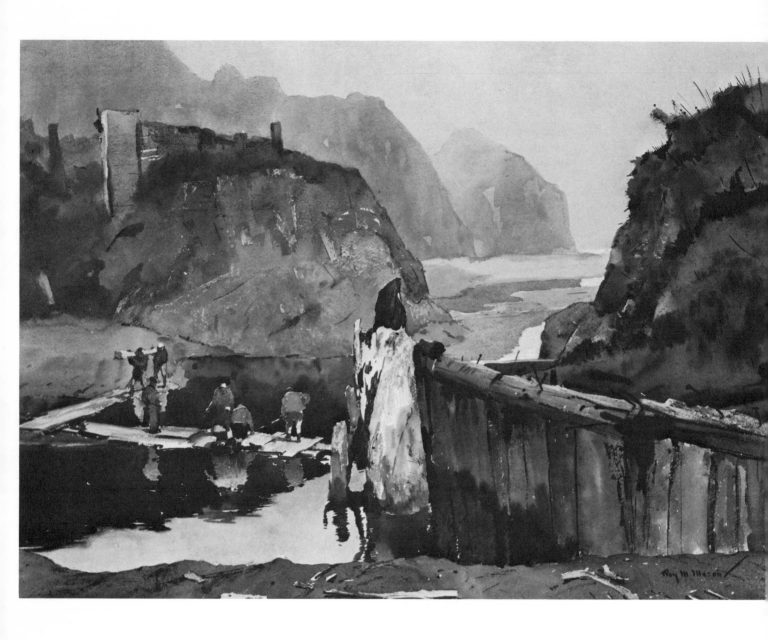

Mogadore by Roy M. Mason, watercolor.

In a complex landscape like this one, it is helpful to visualize the various forms as flat shapes. In this painting, four masses of rocky land jut upward, and each has a distinct silhouette which was considered before any detail was painted in. Within the silhouettes, the artist then added as much detail as he thought necessary: the nearest land mass, on the viewer's right, has the greatest amount of foliage detail; the next nearest, above the figures, has somewhat less detail and less contrast; and the two distant masses are virtually devoid of detail, except for a faint indication of shadow. The area of highest contrast (in the lower left hand quarter of the picture) is the focal point and the artist has relied upon crisp light and dark accents to draw attention here. (Photograph courtesy American Artist)

Values

Some professors of art have talked in a learned way of values or tone. What is value? It is nothing more than the depth or density of one color and its correct relation to the surrounding colors.

COMPARING VALUES

To be as simple as possible, I would refer the student to Plates I and II. These are two examples of values. For the sake of making the definition clear, these two landscapes have four tones—foreground, middle distance, distance, and sky. In either example, every detail of color or form in the foreground must be of the right density or the right depth of color. The paintings would be failures in this respect if any portion of the landscape, say in each foreground, appeared to belong to the middle distance or the distance. These remarks are equally true when applied to the middle distance, distance, and sky.

The student who goes out sketching will have some difficulty, in the first year's work, in ascertaining the best way in which to manage these four tones. As a general rule, the foreground is darker in color, the middle distance is a little lighter, the distance is lighter still, and the sky the lightest of all. Do not, however, be misled by this statement, because it is possible—but not usual—to have the sky darker even than the foreground. Experience should teach the student the best way of obtaining the desired results of tone. Intelligent thought soon clears away all difficulties. The mind has to assert its control over the student's actions in painting tone.

I do not advise any student in the early days of sketching to try the type of landscape where there is a great variety of tone. As the majority of people know, Turner was a master of values. He was not satisfied in the average landscape pictures to express four tones; most of his pictures show quite a large number of varying tones. But even so, it is possible for the average student to paint a fair number of tones in one picture, provided that he makes a start in the manner suggested on Plate I, and gradually feels his way as experience ripens.

A lead pencil, as well as color, can suggest tone. Some artists use several lead pencils of varying density with which to draw landscape subjects out of doors—a 6B pencil for the foreground, 5B, 4B, and 3B pencils for the varying lighter tones receding in the picture, and sometimes finishing with a harder pencil, such as an HB, for the distant mountains or clouds floating over the sky. If a pencil can suggest tone accurately, it should not be a very difficult matter for a painter to express tone in color.

The two landscapes already mentioned, although of the same subject, show different colors, the idea of the artist being that each color in the corresponding place of each picture should be of exactly the same density or tone. The foreground of the top landscape is as dark as the foreground in the lower landscape. The middle distance in the top landscape is just as dark in tone as the middle distance in the lower landscape. The same remarks apply to the distance and the sky. Allowing for reproduction, which is nearly perfect in these days, the author of this book claims that these two landscapes are a very fair representation of similar values.

LEARNING ABOUT VALUES — It is instructive to try several watercolor tints of different colors on one sheet of paper and see if each tint can be made of the same depth or density as the adjoining tint.

A wash of yellow ochre could be washed side by side with a wash of pearly gray; burnt umber may be washed by the side of dark gray, or a tone of light red could be washed by the side of purple. Students should keep on practicing in this way, trying to get the same depth of tone, although a fresh color is used in each wash. Eventually, when the student goes out of doors to sketch, the mind is under control as regards the possibilities of tone in nature.

There may be a rare subject in which value is of less importance; that is a matter for the student to decide. Even so, there is a certain tonality in an apparently chaotic picture, which may not represent the orthodox feeling of tone as seen in nature.

A small white cardboard mat (the width of the mat, say, 2″, and the opening about 8″ x 10″), if held up to nature out of doors, will help the student to see the tonality of the subject. This will also help the student to compare the tone of the sky with that of the distant hills, fields, houses, foreground, or whatever is contained in the subject which has been selected for sketching.

It is impossible for the student to show decisive values in any landscape if he will insist on paying a lot of attention to unimportant detail. The tone of a tree is quickly seen if painted in the first instance in a flat mass; the tone of a distant mountain is at once evident in its relation to the sky if painted perfectly flat in the first stage of the painting. The same with the foreground, or any other important features in a landscape. It nearly always pays students to paint in all the tones as if they were doing a design for a flat poster. When that is accomplished, step away from the sketch some two or three yards, and compare all the flat tones with the tones of nature itself. If these tones are found to be accurate, then the student can put in a certain amount of detail; but whatever detail is used, it must not, on any account, break up the unity of the picture. That is the whole problem that confronts the student, and it is a big problem.

Of three examples given of values, the first, entitled A *Gray Day at Bruges* (Plate III), is far more difficult to represent from a natural standpoint than the second, *The Bridge over Bruges Canal* (Plate XXXI). This first picture has nothing definite for the artist to work from as regards light and shadow. It is true that there is a shadow under the bridge, and that there is some design in the picture, but as there is no positive light, a great deal of observation was needed to convey the correct values. To take a small point, such as the figure on the bridge with the reddish-purple cloak—if that figure had been much lighter in color, it would have come away from the bridge and been quite out of tone. Or if the boat beneath the bridge had been twice as light in color, then the boat would not have been resting on the water. It would have appeared as if it were in the air above the water. The lightest portion in the immediate foreground on the water, namely, the reflections of subdued light, had to be very carefully rendered as regards density. Every color relating to the surface of this water must be exactly right in light or depth, so as to keep the water one flat surface.

Unity is achieved in this pastel painting through the restraint shown over the whole of the picture. A certain amount of daring was used in the lighter touches of the pastel by suggesting the drawing of the stonework around the arch of the bridge. These few light touches would have lost their purpose if many more light touches had been added in the same neighborhood. The student, then, has to learn the adroit use of light, whether it be brilliant or subdued. It is nearly always safe to do too little than too much.

To take the second subject demonstrating values, the picture entitled *The Bridge over Bruges Canal* (Plate XXXI,), this is a vastly different proposition, and ever so much easier. The brilliant light on the house immediately behind the bridge, in the center portion of the picture, made it comparatively easy for the artist to determine the tone of the bridge, the tone of the shadow below the bridge, the warm grays and yellows in the water, and the colors of the right hand building. The positive depth of color used in the foliage of the tree, and the trunk, with the two figures below, rendered everything quite a simple problem. It is possible that the depth of the sky has been slightly exaggerated, but as the light is so brilliant on the house immediately behind the bridge, the feeling of the painter, when sketching this picture out of doors, was helped by this possibly exaggerated tone of the sky in order to enhance the strength of sunlight on the building.

The third example of values, *The River Doubs, Besançon, France,* (Plate IV), is a sensitive subject as regards the general distribution of light colors.

The tonality of the road in the lower foreground, which is light in tint, retains its place (although quite as light as the distant hills) through the warmth of its color. The darker bushes adjoining the road, being low in tone, are invaluable because, through tone contrast, they cause the river, hills, etc., to take their correct places in the picture. Had these bushes been painted a little lighter or a shade darker, the picture would have been a failure if judged from the standpoint of values.

A very light groundwork was used for the first stage of this watercolor painting, consisting of a mixture of yellow ochre, white tempera, and ceru-

lean blue. The tint of the sky was painted from the top of the picture down to the water's edge. While this color was still wet, the hills extending right across the picture were painted in with a flat watercolor brush. Detail, painted on wet color, was added to the hills towards the left. With the exception of the river, the foreground consists of pure transparent washes, the drawing of the bushes towards the right being strengthened with sharp touches of dark violet.

In the analytical diagram of this picture (adjacent to Plate IV), the chief point of interest is the way in which the lines of the river connect the foreground with the middle distance and extend to the foot of the distant hills. The dotted curves explain the composition of this picture. Notice how the dotted curve which sweeps across the river carries the rhythm of the middle distance into the foreground.

There are altogether twelve different analytical diagrams of this sort in this book, showing clearly the construction or composition relating to the corresponding twelve color plates. This number should be quite sufficient to make it easy for students to understand the underlying principles of construction that may be seen in other pictures.

It is a good plan, when visiting art galleries and museums, to make pencil notes of well known landscape pictures, indicating the main features of compositional lines and other items of general interest.

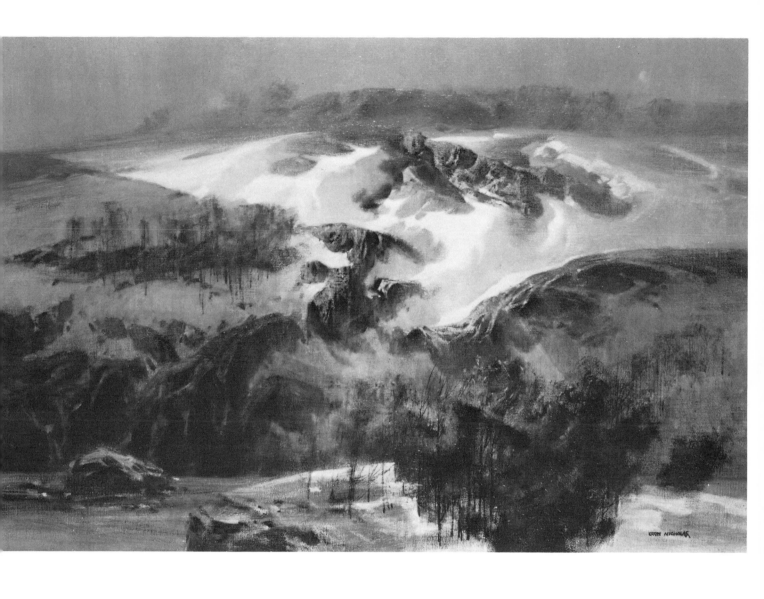

WINTER LANDSCAPE by Tom Nicholas, oil.

Because nearly all of this dramatic landscape is in shadow, the viewer's eye is drawn immediately to the snowy area which catches a flash of light from a break in the overcast sky. The snow is not merely a flat area of white, but is carefully modeled in planes of light and shadow. Note the extremely selective use of detail and finish. The trees in the foreground are scrubbed in very roughly. Much of the landscape is simply blocked in and left in a semi-finished state. And the forms on the horizon are merely blurs of tone. Only the central rocks and snow are painted with real precision. Thus, the viewer's attention is directed not only by selective lighting but by selective finish. (Photograph courtesy American Artist)

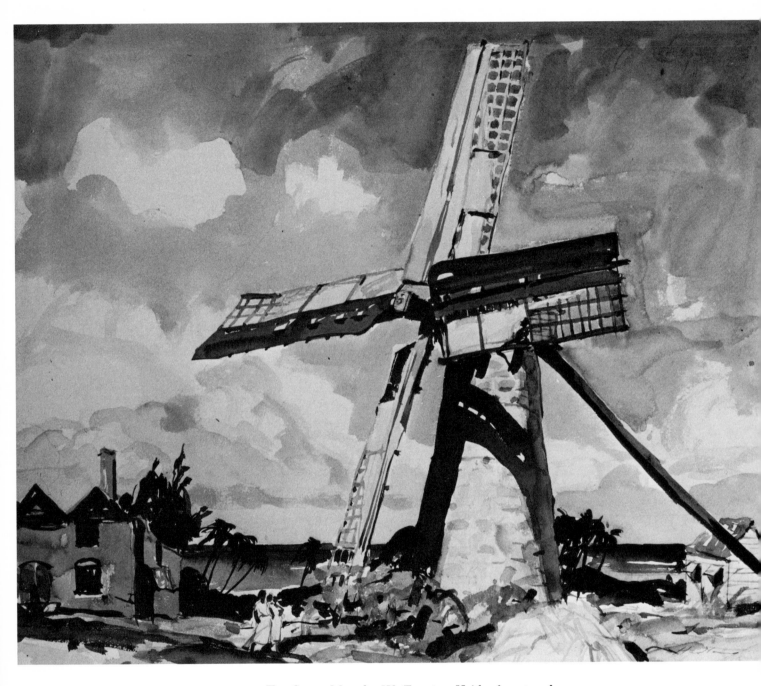

THE SUGAR MILL by W. Emerton Heitland, watercolor.

The central element of the picture, the mill, is essentially geometric and the painter has contrasted the rectilinear lines of the mill with the free, washy forms of the sky. In painting landscapes with architectural elements, it is often wise to emphasize this contrast of free forms and rigid forms. The artist has also paid careful attention to the direction of the strong tropical sun, which throws a dark shadow around the cylindrical form of the mill. This strong directional light also enables him to render the distant trees as dark silhouettes emerging from a strip of shadow. (Photograph courtesy American Artist)

Outdoor Sketching

For outdoor sketching, the simplest and lightest outfit, whatever the medium used, is the best for all intents and purposes. In mountainous districts, anything in the form of weight becomes so physically distressing after traveling for some distance that there is not much energy left to make any sort of sketch from nature. It is almost equally true that when traveling, even in normal districts, with a heavy sketching outfit, the weight thereof is inclined to destroy all feeling of response for anything that nature may have to say to the artist. From an economic standpoint, the lighter the weight the cheaper the outfit.

As hinted elsewhere in this book, the student who wishes to express individuality cannot get too much knowledge of natural form, color, and detail. Outdoor sketching means something more than passing a few pleasant hours a week copying nature. The subject is too big for feeble application. In good weather, go out sketching not less than twice a day. Utilize the whole morning, when the light is good; slack off work for a couple of hours, perhaps, at midday; and then fit in the remainder of the day, doing at least another two sketches. A good average for three months' work, if the climate be suitable, is three sketches a day. To achieve that, one sometimes has to make five sketches in one day so as to allow for bad weather. There is every prospect, if the student has artistic leanings, that by adhering to the average output of three sketches a day, he will become a good landscape artist.

COLOR SKETCHES AND PENCIL DRAWINGS

Chapter 5 on values gives practically the keynote to outdoor sketching. The placing of correct tone against tone is invaluable when reference is made later in the studio to the sketch. Little more can be desired than good tone in a sketch, combined with very careful pencil studies so as to back up the outdoor color work. In fact, every sketch should have its corresponding pencil drawing. Personally, I find the pencil drawing sometimes more useful than the colored sketch, but that is only because of the knowledge gained after having painted some thousand odd sketches out of doors. It is much better

for the student to show boldness with the paintbrush than it is to paint in a timid style. Concise work, or clear statement, achieves far more than inefficient earnestness in rendering natural effects.

MEDIA FOR COLOR SKETCHES To sketch in oils, little time is required for any sort of preliminary drawing. An oil paintbrush, provided that the first coat of paint is thin, is quite capable of building up a practical sketch, suggesting proper draughtsmanship. To sketch in watercolor, it generally pays to draw carefully all the main outlines of mass formation and a good proportion of the detail before coloring.

It is also a very good thing for the student to sketch in pastel. Many students commence their sketching career in watercolor, which is probably the most difficult medium of the three. Certainly, it does not help to accelerate the speed of the student along the path of art.

One advantage of sketching in pastel is that mistakes are very quickly remedied. If the whole sketch is wrong, a rag or bristle brush will flick out most of the offending colors, and the ground-work caused by that brushing off of color is sometimes perfectly delightful to work on. It is also very suggestive. Indeed, it is inclined to make the work too artistic, if such a thing be possible.

BE DECISIVE When strolling around, looking for an appropriate subject to sketch, one is often mentally excited by some passing effect which has a strong artistic appeal. I have nearly always found it a fatal error not to commence work at once while that effect still held good. It is a mistake to walk forward or backward, or to stroll around seeking a fresh subject, when one has already been discovered, thinking perhaps the next will be better. The next never seems to come. Therefore, when searching for a subject, as soon as something thrilling happens to you, sketch right away without a moment's hesitation. This not only saves time, but it makes for inspirational art.

The second difficulty which arises is that, having found the subject, and completed a portion of the sketch, the student is often, through technical difficulties, inclined to wander away from the first mental impression. There is nothing worse than a sketch which shows two or three thoughts of a contradictory nature. A sketch should have one definite message which rings throughout the whole of the painting.

The third mistake that misapplied sincerity makes is to sketch on the same subject so long that the sun has moved its position; shadows are in a totally different place, and the whole thing has become messed up from a logical standpoint. Too much speed in sketching is desirable rather than a slow and laborious effort.

Weather conditions have always to be taken into account. Yet, although sunlight is usually much to be desired for outdoor sketching, a resourceful artist can overcome nearly every obstruction that may occur.

One of my sunniest pastel paintings was made when sheltering from the rain, by sketching under a doorway leading into a shop. The subject was a market scene with various groups of figures and local buildings. The absence of definite light and shadow created the necessity for invention and design. So well balanced did this sketch become, with an arrangement of imaginary light and shadow, that it quickly found its way to a patron of the fine arts.

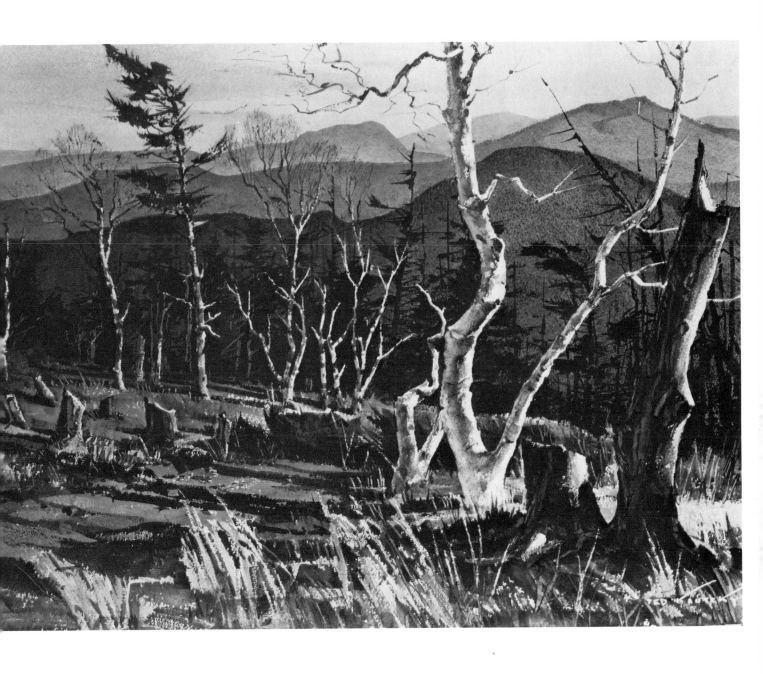

On Mount Mansfield, Vermont by Ted Kautzky, watercolor.

The vitality of this wooded landscape stems from the fact that the artist has caught the subject at a time of day when the light is coming from the extreme right. The trunks and branches of the trees, as well as the weeds in the foreground, are edged with bright, crisp notes of light, which give the painting unusual sparkle. Most landscape painters prefer to work early in the day or late in the day, when the light is coming from the sides or from behind the subject. The most difficult light to paint is at mid-day, when the sun is pouring straight down and filling the entire landscape, destroying form and creating pools of shadow directly under each shape. Side or back light creates roundness of form, divides shapes into distinct areas of light and shade, and produces strong horizontal shadows that indicate the shape and direction of the terrain, as one sees here. (Photograph courtesy American Artist)

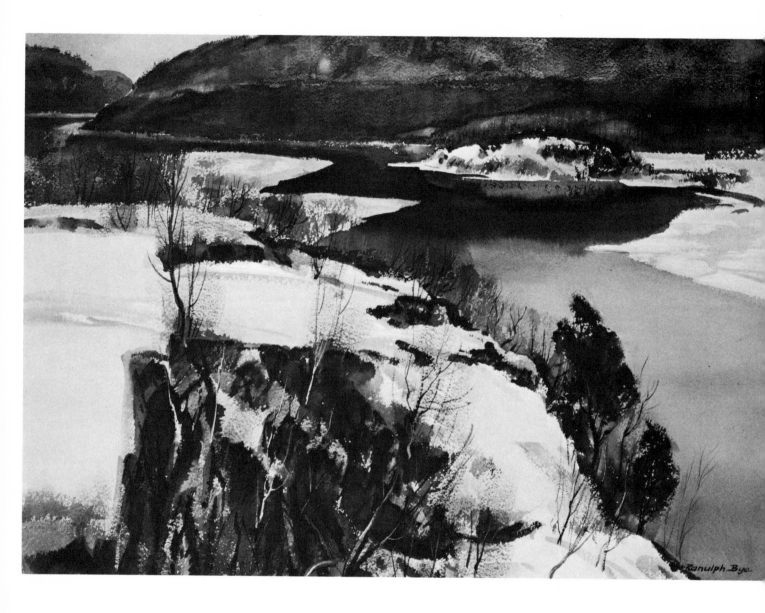

HUDSON OVERLOOK by Ranulph Bye, watercolor.

The winding course of a body of water can be a convenient compositional element to lead the eye of the viewer through the picture. In this winter landscape, the near shore of the river carries the eye back along a winding course from the foliage in the immediate foreground out into the distance. In painting water, it is important to remember that the surface is not a uniform tone, but is enlivened by reflections. Observe how the land mass on the horizon appears as a dark reflection in the upper reaches of the river. At the same time, the mound of snow at the turning point of the river appears as a lighter reflection within the darkness. (Photograph courtesy American Artist)

More about Outdoor Sketching

In Plates V and VI are two watercolor sketches; Plate V was done at express speed in about thirteen minutes. There was no striving for actual facts of nature. It was painted in an utter sense of irresponsibility, with no thought of careful handling or technique. Any artistic virtue it may show is the result of years of practice in outdoor sketching. There is no reason why an artist should not have as easy a command in using brushes, paints, etc., as the well equipped musician—whose technique is only the unseen foundation on which is built the personal interpretation of music—has over his instrument.

DIRECT WATERCOLOR SKETCH

It is possible that this sketch is more artistic than many a studio picture that has taken a month to complete. There is a certain feeling of friendliness between the two trees in the sketch—the one on the left bending towards the one on the right. The latter tree is slightly inclined, with a certain amount of reserve, to respond. The simplicity of coloring is caused through the lack of time to try any other way—just flat, running washes, partly mingling with each other, with the paper showing here and there, which gives a feeling of sparkle that is so difficult to obtain in a picture which has been painted over with two or three washes.

TINTED PENCIL DRAWING

The sketch immediately below (Plate VI) represents a tinted pencil drawing on a piece of ordinary notepaper, torn from a writing pad. The pencil outline is still noticeable in the sketch, and the watercolors were used merely to tint and suggest the tonality of the picture, without resorting to strong highlights or deep shadows.

OIL PAINTING BASED ON A SKETCH

In Plate VII is seen the possibility of a serious oil painting from this little colored pencil sketch (Plate VI). Here we get the tonality of nature, the deep greens of the trees, the dark color of the water, and the deep colors of the roofs of the cottages. By comparing this picture with the sketch, one can

see at a glance that the sketch has artistic virtues of its own, being quite luminous and easily rendered, but it lacks the tone of the oil painting. The oil picture shows a rich, sombre effect of heavy foliage, as opposed to the sun-lit background. It has lost the luminous transparency of the little watercolor.

The following colors were used for the groundwork of this picture, later modified by overpainting and blending.

Sky: yellow ochre, cerulean blue, light purple.

Trees, and roofs of cottages: burnt umber, burnt sienna, viridian, and deep purple.

Water: burnt sienna, purple, burnt umber, raw sienna, yellow ochre.

Hill and stone bridge: Warm gray and grayish purple. A little zinc white was mixed with some of the groundwork colors.

Note that in this and all other examples referring to the colors used for the first stage or groundwork, it must be clearly understood that the colors—whether oil or pastel—are, as far as possible, kept flat in tone, with no blending of one tint with an adjoining tint. For this purpose, the above colors can be kept separate one from the other, allowing the canvas or paper to show through in places if necessary. It is only in the later stages that the blending or dragging of one color over the other is advisable, but even this needs caution. These remarks apply chiefly to studio pictures painted from outdoor sketches.

WATERCOLOR SKETCH IN TWO STAGES

Plates VIII and IX are two sketches of the same subject, painted in water-color, the top one being the first stage and the lower the finished stage. The artist here purposely drew with some care, and all the border lines of the cottage and the contours of the tree were kept scrupulously in their place. The sketch is a cool calculation of a design seen out of doors. Notice how pleasing the color of the paper is in the first stage, particularly the sky, before the final colors were washed in. The same cottage and trees could, of course, have been sketched with less precise drawing, more vigorous color, and deeper tones, particularly as regards the tree on the left.

PASTEL SKETCH FOR A WATERCOLOR

An outdoor pastel sketch (Plate X) I found very useful for reference when painting the watercolor in Plate XVI. This watercolor is designed entirely from the information gained in the pastel sketch. Notice in the original sketch that the outlines of the water meet in a point on the left side. In the watercolor, the water extends horizontally across the whole picture, causing a more agreeable pattern. In the pastel sketch, the color of the foreground is rather heavy, and lacking in delicacy. The watercolor shows improved color and form in this respect. The lighter foreground in the watercolor gives emphasis, through tone contrast, to the rising hill occupying the left half of the picture; also the water, being deeper in color, assists the design, while arbitrary lines were used in other portions of the painting to emphasize the rhythm of the picture. The pastel sketch was made very quickly—just an idea—hoping to create another idea, with no intention whatever of trying to show careful drawing. Any good draughtsmanship which may appear is accidental or innocently obtained—without conscious effort.

The difference between the strength of a pastel and the suggestiveness of a watercolor sketch should be quite obvious to the student when examining the two reproductions in Plates X and XI. They both show their own peculiar virtues. It would be less difficult to make a finished oil painting from the pastel than from the watercolor sketch. The general tone of the pastel sketch is somewhat similar to the tonality of the average oil painting.

Plate XI has one merit—design. The horizontal feeling of the upper and lower clouds harmonizes, and carries on the horizontal spacing of the landscape below. To make a picture from this sketch, I would suggest that the whole of the sky, including clouds, be a little darker in tone, that some of the blue tints should be turned into grayish blue, and that the green fields in the higher portion of the landscape on the left be made more restrained in color. The sky, being darker, would then, through tone contrast, emphasize the light on the sand dunes spreading horizontally across the picture.

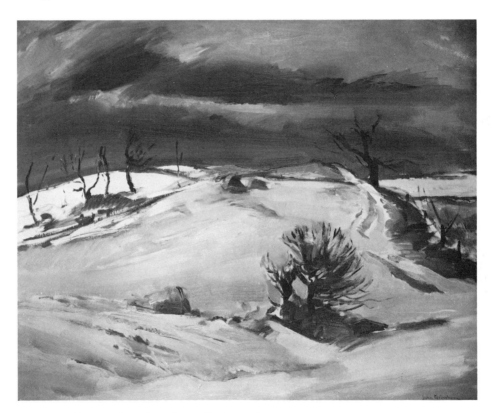

RABBIT RUN by John Folinsbee, oil, 32″ x 40″.

Snow is one of the most difficult of all subjects to paint because the beginning landscape painter tends to forget that his subject is not mere white paint, but contains shadows, textures, and forms. In this painting, the artist has carefully observed that the snow has distributed itself over the landscape in a series of swelling shapes; he has placed trees, rocks, and patches of shadow at strategic points to separate these shapes. Thus, the nearest trees and a single rock indicate where the foreground ends and the middle distance appears. The brushwork is particularly interesting: the broad, sweeping strokes follow the curves of the forms and reveal their roundness. Observe how little of the snow is actually white and how much of it is subtle, constantly shifting tone. The dark, moody sky emphasizes the whiteness of the landscape below. (Photograph courtesy American Artist)

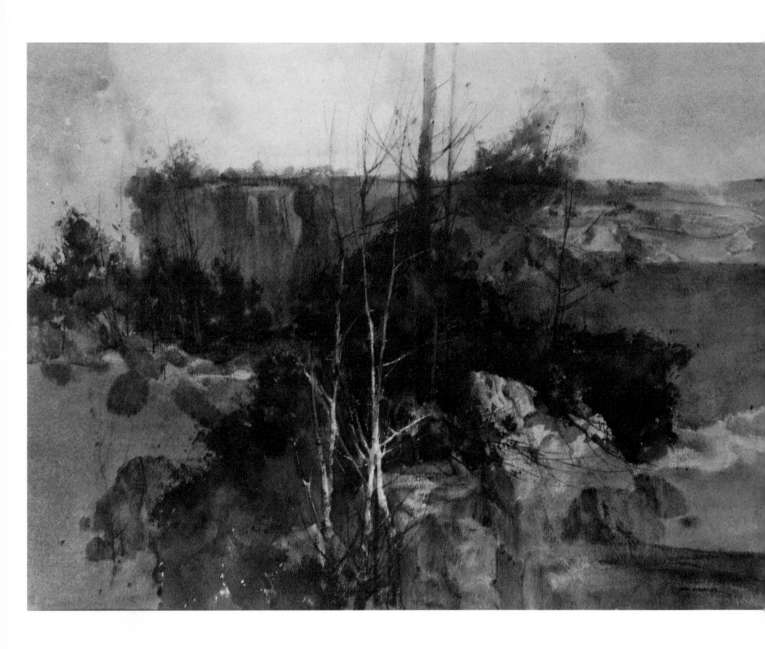

Passing Shadows by Tom Nicholas, watercolor.

The artist has plunged his entire landscape into shadow—as the title of the painting suggests—in order to focus the viewer's attention on a few foreground trees and a rock formation, which receive virtually the only touches of light in the painting, except for the break of light in the sky. The lighted tree trunks are placed before a mass of dark foliage. This is the only point in the picture where the artist has introduced precise detail. The more distant trees and the shape of the cliff melt into the atmosphere and are put out of focus, like the background of a photograph often appears to be. The outer edges of the composition, and particularly the corners, contain no detail at all and are nothing more than patches of tone. (Photograph courtesy American Artist)

Detailed Studies in Pencil

In this chapter, I will discuss four studies in pencil made out of doors—the first an elm tree, the second the Château de Polignac, the third the Château de St. Voute, and the fourth several pencil studies of incidental outdoor subjects. These are included in this book merely to show students that careful pencil drawings are part of the art student's outfit if he wishes to achieve good landscape painting. It is best to use at least three different pencils, varying in degree of hardness or softness. A 5B, a 3B, and 1B make a good repertoire for the pencil artist. Sometimes, for hard outlines, an HB, which is not liable to smudge under normal conditions, although less artistic, is useful for giving a truthful account of material facts.

TREE STUDY In making the study of an elm tree (Fig. 33) in pencil, the artist left out quite a lot of detail, yet on the other hand, there is enough information in relation to the shape of the branches, the general growth of the tree, and the massing of the whole, to make this drawing far more valuable than any photograph of the same subject could possibly be.

Apropos photography, it is a curious thing that the lenses seem to take in everything that is not wanted and obscure the main issue. A pencil draughtsman instinctively gets just what is required for the subject of the future picture. Pencil drawing is an art unto itself.

TWO LANDSCAPE STUDIES The drawing of the Château de Polignac (Fig. 34) was made principally not only for the contours of the château, but for the various groups of trees and cottages and other buildings grouped around the château above.

The drawing of the Château de St. Voute (Fig. 34) has a certain amount of sparkle in the little trees in the foreground. The illusion of light on the roofs of the lower houses at the foot of the château was obtained by shading the walls and leaving the roofs free of pencil lines, while the lighter tone of the distant drawing, with the delicately suggested clouds, has all the accessories necessary for an experienced artist when working in the winter months.

Fig. 33. *Study of elm tree leaves out detail, emphasizes mass.*

Fig. 34. *Pencil study of Chateau de Polignac.*

Fig. 35. *Pencil study of Chateau de St. Voute.*

Fig. 36. *Page of pencil studies of incidental details.*

HOLD THE PENCIL NATURALLY Pencil drawing is liable to create difficulties for the average student unless the pencil is held in an easy manner. The least attempt at gripping a pencil tightly, or at holding it like a pickaxe, is fatal for natural draughtsmanship, or easily rendered drawings. I have seen students, not knowing that the pencil they were drawing with was held in a clumsy manner, looking quite depressed in trying to copy a maze of detail out of doors. It is a peculiar fact that as soon as a pencil is held somewhat loosely, and the hopeless attempt abandoned of trying to rival the camera in the matter of detail, the result is far more faithful to nature because of the more fluent linework, which is only possible when the pencil is used naturally.

PENCIL NOTES The nine pencil reproductions in Fig. 36 are invaluable for the information they contain. Students would do well to have their notebooks full of all sorts of outdoor subjects. Apart from their use for picture painting in the studio, notes of this character should have an art merit of their own.

Pencil drawings which are to be used as aids to picture making in the studio need only be done in outline, with a few simple shadows. This, as a rule, gives a more truthful or more reliable help to the painter than any highly finished drawing, as it shows the intricacies of tone, light, and shadow.

At the same time, pencil is sometimes used entirely as a medium for pictorial renderings from nature, and beautiful, too, are the results at the hands of a capable artist who understands the possibilities of pencil art.

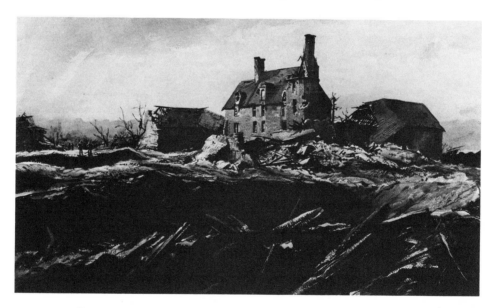

BOMB CRATERS COLLEVILLE SUR MER by Ogden M. Pleissner, watercolor.

Because of their romantic appeal and jagged forms, ruined buildings often make more interesting subjects than buildings which are intact. The power of this landscape stems, in part, from the artist's choice of a strong light that enters the picture from a low angle at the extreme left. The light strikes the left hand planes of the buildings and leaves the right hand sides in pools of deep shadow. In the same way, the light creates strips of brightness on the landscape and leaves touches of light on the wreckage in the foreground; but most of the landscape consists of great pools of shadow. By contrast, the sky is extremely pale, with only a touch of cloud. (Photograph courtesy American Artist)

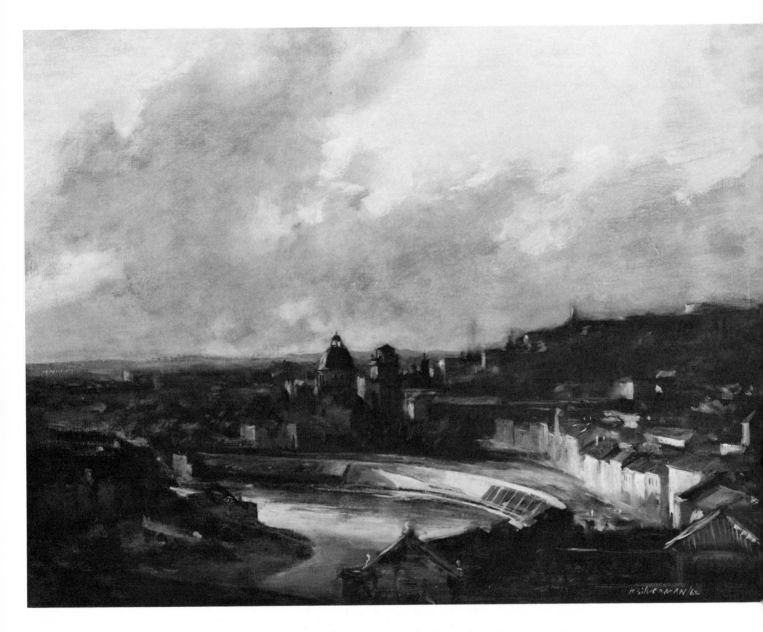

VIEW OF VERONA by Burton Silverman, oil, 23″ x 31″.

A panoramic view of a landscape with architecture can be difficult to compose because of the multiplicity of detail. Here the artist has solved the problem in several ways. First, he has kept detail to a minimum in most of the landscape: look closely and you will see that nearly everything is rendered in patches of broken color, with very little attention to specific rock formations, masses of trees, or shapes of buildings. Second, he has thrown most of the landscape into shadow, with just a few touches of light to illuminate the group of buildings at the center of interest, and to swing the viewer's eye along the river bank to the central dome that breaks against the sky. Third, he has decided on a low horizon, so that more than half of the picture is actually sky, with the cloud formations organized to draw attention to the cluster of buildings beneath. (Photograph courtesy American Artist)

Studies of Clouds

So many students, when sketching cloud effects in watercolor, handle their medium with greater success than they paint the landscape below. The lower portion of the sketch is often overlabored and not always clean in color, whereas the sky has escaped such a calamity. They probably feel a sense of irresponsibility when tackling clouds and ordinary sky subjects. If they had this sense of irresponsibility sometimes when sketching trees, fields, buildings, and so on, their technique would not bother them quite so much. All the same, the study of clouds needs definite concentration. There is nothing more satisfactory than a picture of clouds in a landscape where the subject has not been under the technical control of the student who painted them. Clouds need as much designing as a good carpet pattern.

MEMORY AND INVENTION — The picture in Plate XII shows a study of clouds. The preliminary study was done out of doors direct from nature, but the wind was so great that the effect seen in this picture lasted only a few minutes. It is here that a scheme for design, as well as a trained memory for natural effects, comes to the rescue of the artist. Without the facility for some invention, it is almost hopeless to get a satisfactory study of clouds when the wind is blowing at the rate of some forty or fifty miles an hour.

The design of this picture helps the illusion of movement. The larger cloud on the top left side swings in a downward direction towards the right, so as to connect up the clouds near the horizon and the dark hills with the adjoining landscape below.

SKY AND CLOUD COLORS — This watercolor study was painted with a good deal of body color (opaque white). The following colors were used.

Sky: Grayish blue, yellow ochre, and a little crimson. Each of these two colors was mixed with a small quantity of white tempera.

Hills: Permanent blue and warm gray. Blue was mixed with a little permanent crimson.

Trees: Hooker's green (middle tint). Deep Hooker's green was mixed with burnt umber. Deep Hooker's green was also mixed with burnt sienna.

Foreground: Mostly yellow ochre mixed with a little raw sienna and laid on with transparent washes.

The cloud tints immediately above the hills were carried over the surface of the hills in places, while the colors were still wet and amenable to treatment.

Body color (white tempera, gouache, designers' colors, Chinese white) is an excellent medium for blending one color into an adjoining tint without leaving a scratchy surface.

In the final stage, permanent blue was added to the contours of the trees, towards the left, with yellowish or russet green in portions of the foreground.

CATCHING FLEETING EFFECTS

The first impression out of doors was made with considerable rapidity in pastel, on tinted paper. How important it is for the one who works at great speed to have a constructive sense! As suggested in Chapter 2, the pursuit on winter evenings of creative designs, whether of sky or any other form of landscape, is of real use when working under some form of emotional excitement.

A successful cloud study on a windy day asserts its success in the fact that, when one looks at the sketch, the clouds still appear to be moving. The artist does not claim such a high standard in this picture, but he does claim that the design itself suggests that nature was not in a state of placid tranquillity.

GRADATED COLOR

Plate XIII shows a gradated color scheme, starting at the top with rather deepish blue, gradually becoming lighter, and changing its color, until it reaches the lower portion of the sketch.

The watercolors used for this prepared groundwork were mixed in saucers, preparatory to painting, and the paper was well damped in advance. While the colors were being washed on, the paper was tilted at a slight angle to allow the colors to blend naturally. Not only is this good practice in watercolor, but it is also very useful in preparing a ground for painting a cloud study in this medium.

Plate XIV is precisely the same sky, done in the same gradated manner, but the lighter clouds were washed out with a little sponge. The intention here is to show that there is a certain amount of aerial perspective in the size of normal clouds. The clouds at the top of this picture are larger in dimension than the clouds in the central portion of the picture, and they become smaller and smaller until they reach the horizon. The landscape in the foreground was painted on purpose to prove that the tone of the darker clouds was not too strong for the earth below.

It is admirable practice to paint quite a number of imaginary cloud studies indoors. This will give control of any medium that the student is interested in, and it will also help the mind to receive some advance information as to what nature may be up to when sketching out of doors.

It is not advisable to paint a naturalistic picture of clouds on a sky where the tone is the same all over, rather than gradated. Sometimes, in posters, the whole sky is painted in one flat tone, which serves another purpose.

The student will discover, in looking carefully at nature, many different tone qualities in the sky. The early morning sky is different from the midday sky, and so on. According to scientists, there are three primary types of clouds, which are easily recognizable.

(1) *Cirrus:* showing parallel, flexuous or diverging fibers, extensible in any or all directions.

(2) *Cumulus:* representing convex or conical heaps, increasing upward from a horizontal base.

(3) *Stratus:* a widely extended and continuous horizontal sheet, increasing from below.

There are four derivative or compound forms.

(1) Cirro-cumulus.

(2) Cirro-stratus.

(3) Cumulo-stratus.

(4) Cumulo-cirro-stratus, or nimbus.

Clouds, despite their classification in science, are nevertheless capable of an extraordinary number of variations in their forms, to which there seems to be no limit. If there were only some five or six definite shapes in clouds, then it would be interesting for the student to invent others; but as an experienced landscape artist I know that almost any form is possible in nature.

A sky painted without any clouds and with a lowlying horizon makes an impressive landscape. It is fairly obvious to most students that horizontal clouds create a feeling of tranquillity. Some of the best pictures of the more sumptuous type of clouds have been painted when the artist has worked at high pressure.

Over-modeling of a cloud is not at all pleasant in a picture. The student is advised to keep dark clouds fairly flat in tone. The same remark applies to the sky and to the lighter clouds. The darkest cloud is usually considerably lighter than various features seen in the landscape. A dark reddish-brown rock, say in the foreground, which has escaped the rays of sunlight, is much darker in tone than the darkest rain cloud that nature has ever shown. I have, however, seen a yellow cornfield in the foreground much lighter in tone than a distant cloud, caused through the rays of brilliant sunlight; but without the aid of sunlight, the tone of foreground objects, and even sometimes of the distant objects, is invariably darker than anything that the sky or cloud has to show.

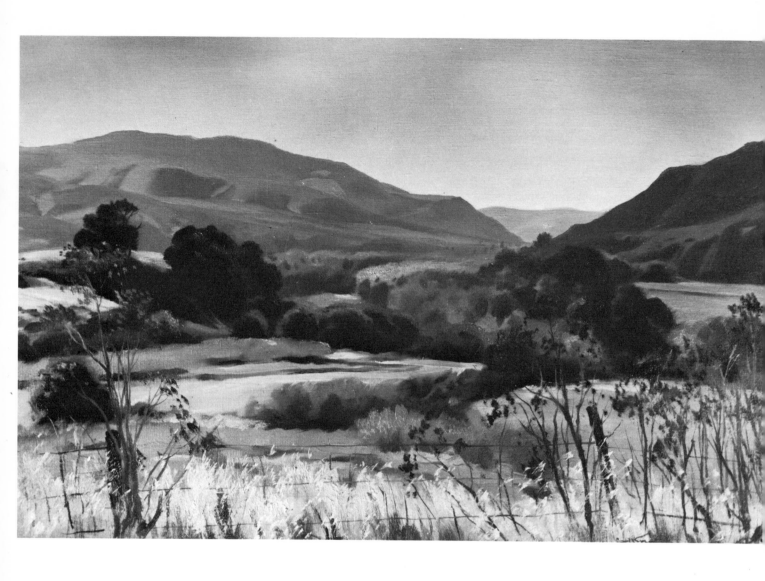

EARLY SUMMER by Emil J. Kosa, Jr., oil.

Here is a particularly clear example of atmospheric perspective, in which the picture is carefully divided into foreground, middle distance, and distance. The growth in the immediate foreground is rendered in sharp detail with precise contrast of dark and light. Beyond this is the plane of the trees, which are the darkest notes in the painting. And beyond the trees are three mountainous forms, each a separate and distinct shade of gray to indicate its placement in space. The farthest is the lightest. The most distant is also entirely lacking in detail. (Photograph courtesy American Artist)

Studies of Hills
and Mountains

In dealing with this chapter on hills and mountains, particularly mountains, the student should avoid the ideas demonstrated in Chapter 15 on "Undulating Landscapes." Mountains are so important in themselves and appear to have a mental atmosphere which almost forbids any feeling of a rhythmic or lyrical nature. I trust that the student will realize that anything in the nature of ordinary charm—relating to mountain subjects—has no place in a good pictorial conception of mountainous material.

AVOID FALSE CHARM　In days gone by, quite a number of painters would ruin a most excellent mountain subject by showing, on the lower part of the mountain, a quantity of charming purple heather, with the top portion of the mountain sometimes lost in mist or fog, so that by the time the picture was finished, what with the heather and the mist, the original message of the grandeur of the mountain was entirely obscured. It is better to ignore all unnecessary clothing, if the student wishes to emphasize the structural formation of mountain subjects. A mountain in Switzerland or in Canada, of some ten or twelve thousand feet high, weighs, as the average student knows, millions or billions of tons. It is the painter's business, then, to convey that feeling of immensity of weight, as well as beauty of color. The picture of a mountain that shows a texture of a soft, fibrous surface, with part of its beauty lost in mist, and with so many charming surface accessories spread over its body, is almost incapable of showing the fundamental meaning of the subject, and rarely expresses the psychology of the mountain.

Some artists of today are successfully rendering mountain subjects. They are stripping the mountain bare of all superfluities and making manifest the spiritual essence. The old fashioned calendar picture has no place in the mentality of painters with modern tendencies.

EMPHASIZE RUGGEDNESS　The picture in Plate XV, entitled *Cathedral Mountains, Canadian Rockies,* is a fairly good example of aggressive rock-like formation. The sharp angu-

larity of the top portion of Cathedral Mountain triumphs over the encroaching snow and ice. While it is true that these peaks are partly hidden by mist on some days, the character of the mountain should still be retained even so. In this picture, the sketch was done when every portion of the mountain was exposed to view.

The first stage of this picture was painted in the same manner as *Emerald Lake, Canadian Rockies* (Plate XVII). It is worth noting that the greenish tint of ice, visible in the snow immediately below the highest peak, was first painted with a coat of yellow ochre mixed with a little white paint.

The following groundwork colors (modified by later color applications) were used in this oil painting.

Sky: yellow ochre, warm gray, cobalt blue, zinc white and viridian mixed.

Distant mountains: raw umber, raw sienna, cobalt blue mixed with a little permanent crimson, burnt sienna, terra verte mixed with a little zinc white.

Snow: yellow ochre and zinc white.

Snow in shadow: Dark warm gray, purple.

Foreground mountains: Burnt umber, burnt sienna, deep purple, dark warm gray.

Another view of this mountain, which is not represented in this book, has on its upright surface a horizontal band of different colored rocks, about two thirds of the distance from the higher peak to the snow's edge below. This band suggests a geometric form such as might be seen in the design for the border of a carpet. As suggested before in another portion of this book, geometric shapes are very often beautiful and are always interesting.

The analytical lines of this picture (adjacent to the color plate) demonstrate unity of design, despite the number of angular forms which assert their existence in the top portion of the picture.

All the topmost peaks of Cathedral Mountain are bound together in the dotted marginal line, which extends in an outward, or convex direction. The opposite effect is gained below, as the lower masses of rock formation at the foot of the picture extend in an inward, or concave, direction.

MOUNTAINS
IN WATERCOLOR

Plate XVI is a watercolor entitled *A Decoration* (designed from the pastel sketch in Plate X). The leading constructional lines in this picture are shown in the diagram adjacent to the color plate. They are of a harmonious character, supported by the horizontally straight line extending right across the lower portion.

The following groundwork colors were used in this picture.

Sky: ultramarine blue well diluted with water.

Dark hill: purple (made by mixing cobalt blue and permanent crimson), yellow ochre, burnt sienna.

Light hill and foreground: yellow ochre and warm gray (middle tint), painted strongly on damp paper.

Water: cobalt blue, viridian.

In the final painting, the highlights were painted with thick tempera white mixed with yellow ochre, etc. All the trees, whether light or dark in tone, were painted on top of the first stage. The darker toned trees were painted two or three times over, so as to get the rich tone effect as seen in the reproduction.

MOUNTAINS IN OILS The oil painting entitled *Emerald Lake, Canadian Rockies,* is shown in two stages. In the first stage (Plate XVII), the general design, strengthened by flat color tones, is painted in a decisive manner, practically all the colors being kept darker than those seen in the finished picture (Plate XVIII). It is most important to remember that snow subjects, whether in oil or in pastel, need a warm colored underpainting, consisting of yellow ochre and white, so that the final coat of lighter colored paint echoes some of the warm color below.

A large surface of pure white paint, representing snow, and painted direct on a raw canvas, looks more like a representation of dry white chalk.

The finished picture shows the addition of lighter tones, painted generally over the mountains and snow, while the trees received more detail, and the surface of the water is more broken and luminous.

The diagram relating to the oil painting of *Emerald Lake, Canadian Rockies* (Plate XVIII) illustrates precisely the same principle of convex and concave construction as shown in the Cathedral Mountain picture (Plate XV). The tops of the mountains demonstrate convexity, as seen in the dotted lines and the central portion concavity. The rigid horizontal lines, denoting the boundaries of Emerald Lake, support the great weight of mountainous material above.

When painting hills, which might be described as juvenile mountains, there is less cause to resort to drastic measures representing weight or volume. There are some types of mountains, particularly in the Canadian Rockies, where the student has only to sketch and faithfully copy the original mountain, with its formation and its detailed suggestions, and the resultant picture might be classified as "modern art." This is due to the fact that some mountains have such unusual formation, and appear "modern" in their suggestion of dynamic force, their cubistic angles, and their suggestion of geometric detail.

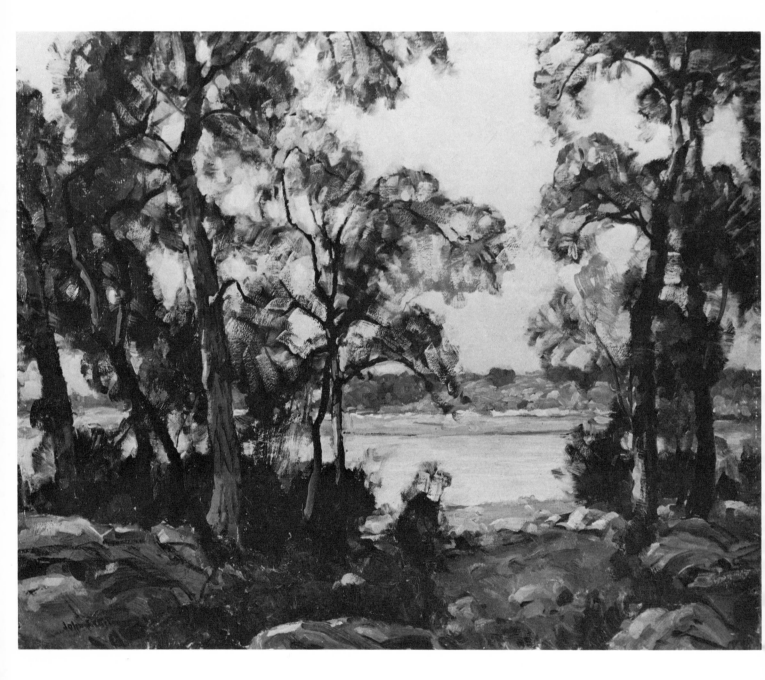

TREE RHYTHMS by John F. Carlson, oil.

Tree trunks (except in a pine forest) are unlikely to be parallel vertical forms, but tend to sway to right and left. In the same way, clusters of foliage tend to have a distinct direction. Here the artist has designed his picture to take advantage of the rhythmic tilt of tree runks to right and left; his strokes indicate the "gesture" of the foliage, which interweaves with the rhythm of the trunks. In painting a wooded landscape such as this, it is often good strategy to allow the viewer to look through the trees into a vista beyond; this creates a welcome break of light in the darkness of the forest. One should also be careful to allow frequent patches of sky to appear through the foliage itself. (Photograph courtesy American Artist)

Studies of Trees

Time and time again, when taking students out sketching, I have been told that they are unable to sketch trees in color from nature. They are quite sure it is a very difficult subject, and, being so sure, they really find it difficult. As soon as that idea is cut away from the mind, it becomes comparatively easy. The student is quite as important as the tree which he wishes to sketch—perhaps more so.

IMPORTANCE OF SILHOUETTE

The reason why students have shown some timidity or modesty in painting trees is because they are clearly conscious that trees generally have a very lavish display of leaves, an intricate number of branches, and a trunk which is easier to draw than paint.

The character of a tree should be known, apart from any detail whatsoever, by its silhouette form when seen against the sky or some lighter background. The fir tree is easily discernible, even at a distance, from a weeping willow. This has nothing whatever to do with the detail of the trees just mentioned; it is simply the fact that the general mass determines the genus of the tree. As soon as the student understands this, and paints the *mass* of the tree rather than the leaves, then he has partly solved his problem, and the sketch can be made in a workmanlike manner.

ELIMINATE DETAIL

It is distressing to see a sketch of a woodland scene where one is unable to see the trees for leaves. It is worse still to see a sketch of a tree where the main features of the tree are entirely lost through the sincere effort of the artist to paint its clothing in faithful language. How interesting a sketch of a tree can be when all detail is eliminated and only the salient points are exposed by the artist!

I have sometimes hurt the feelings of a student very much indeed by taking the paintbrush from his hand, and working all over a careful study of a tree which was quite wrong in tone value, and painting out nearly all the mis-applied detail. This feeling of the surgeon's knife is sometimes necessary if the operation is to have a successful result.

Painting trees, then, requires a certain amount of moral courage in the beginner. A photograph easily gives all the detail which it is possible for the lens to show. The roughest sketch of a tree sometimes conveys more of the psychology of that tree than the most careful rendering in pencil or color can give. Personally, I find it useful, after finishing the sketch of a tree, to make little drawings in my notebook of any important feature that I feel might be useful when painting the finished picture indoors. Chapter 8 shows, to a certain extent, what I mean. Here you see various studies in pencil from nature, including trees, made after I had completed the colored sketches.

There is something magnificent about the elm tree. It is dignified and restrained in color. Trees are analogous in their character to human beings. Often in nature one sees a group of stately elm trees, and sometimes, grouped in front, may be seen little delicate willow trees, lighter in tone, lighter in foliage, and physically more fragile, supported by the darker toned and friendly elms behind.

STUDIES OF MASS FOLIAGE

Plates XIX and XX are two stages of a study of mass foliage, showing quite clearly the first stage painted with flat tints. The final stage was gained by adding strongly defined shadows of deep color.

Students are advised to copy this example in watercolor, and then design some mass foliage of their own on which to practice painting.

Indecision of handling is fatal if the broad effect is sought, as seen in the reproduction.

Plate XXI, reproduces the watercolor entitled *Elm Trees at Windsor*. After mastering the mass foliage example, students should profit by copying the elm trees in this picture. The same principle of flat color painting as in the previous example can be applied here, the darker toned shadows in the foliage of the elms being added in the final stage.

This watercolor was painted on thick paper, and the following foundation colors were used in the preliminary stages.

Sky: light yellow ochre, light ultramarine blue.

Trees: deep Hooker's green mixed with a little yellow ochre, purple, permanent blue.

Distant buildings: yellow ochre mixed with light gray; light purple mixed with a small quantity of yellow ochre; vermilion mixed with light gray.

Foreground: Hooker's green (middle tint) mixed with burnt sienna.

The lower portion of the sky was finished with a small wet sponge for wiping out. The contours of the tall elm trees received the same treatment so as to prevent hard edges.

Blotting paper was used after wiping out, for quick drying and softening effects.

It is a revelation to the average individual who studies trees to know what an astonishing number of different varieties there are. To do justice to this chapter, it would need at least another volume. It is possible that the student who wishes to know a great deal on the subject of trees might suffer from mental indigestion before arriving at that happy stage. Time will bring

experience. For the purpose of this book, then, let the student paint simply and easily, and concentrate solely on the big mass effects.

WOODED LANDSCAPE The watercolor painting in Plate XXII, entitled *Fir Trees, Pas-de-Calais,* is a careful rendering of the characteristic shapes peculiar to fir trees. In the first stage of this picture, the colors were laid on with pure washes, in the final stage, body color (opaque white) was used for the sky and certain portions of the foliage and foreground.

The diagram adjacent to Plate XXII shows the general construction of this picture, emphasizing the sky opening on the right, which is oval in formation and travels upwards to the higher left side of the picture.

The vertical direction of the trunks cuts sharply across the circular formation of the sky opening, affording a piquant contrast, while the winding pathway in the foreground is harmoniously related to the constructional lines above.

STUDIES OF FOLIAGE DETAILS Plates XXIII, XXIV, XXV, and XXVI are four watercolor studies of foliage. The first study (Plate XXIII) is just a flat wash indicating branches and foliage. The second drawing (Plate XXIV) shows the same study with the addition of darker tints both on the branches and on the leaves. These darker tints were added before the first wash of watercolor was quite dry. Here and there, the edges are partly lost, while elsewhere they are definite and strong. Notice how the branches are improved by adding deeper tints in places. This is quite a common feature in nature.

Plate XXV is a colored drawing of the top portion of a fir tree. The same method was used as seen in Plate XXIII and XXIV. The fir, excepting the trunk, is fairly deep in tone, so that the first wash was painted in with low toned colors. The second wash, as before, was added before the original wash was quite dry.

In watercolor painting, it is important to know the exact moment when to add your second tint. There may possibly be some subjects where it is necessary to wait until the first coat is quite dry; but in most studies in watercolor, it is advisable to paint the second wash before the first is dry, so as to create a softer surface, and lose that hard and unpleasant outline which can so easily be obtained if the first color is dry. These remarks apply only to watercolor painting in which no body color (opaque white) is used.

The study (Plate XXVI) was done just outside my studio. This is a study of chestnut leaves. So as to retain the characteristic feeling of the chestnut leaf, considerable time was spent in the preliminary pencil drawing. There may be a certain mannerism in this little study, where darker paint has been used to outline the characteristic shape of the chestnut leaf, but truth in detailed form was sought for, rather than artistic handling.

It is not a very difficult art to make small studies such as these, but, as stated before, care should always be taken so that the student is able to keep under control all knowledge of detail when painting the whole tree. The second or third year's apprenticeship to outdoor sketching should be about the period when the student might be advised to make detailed studies of leaves, branches, etc., from nature without fear of losing the knowledge gained by sketching the more important mass forms.

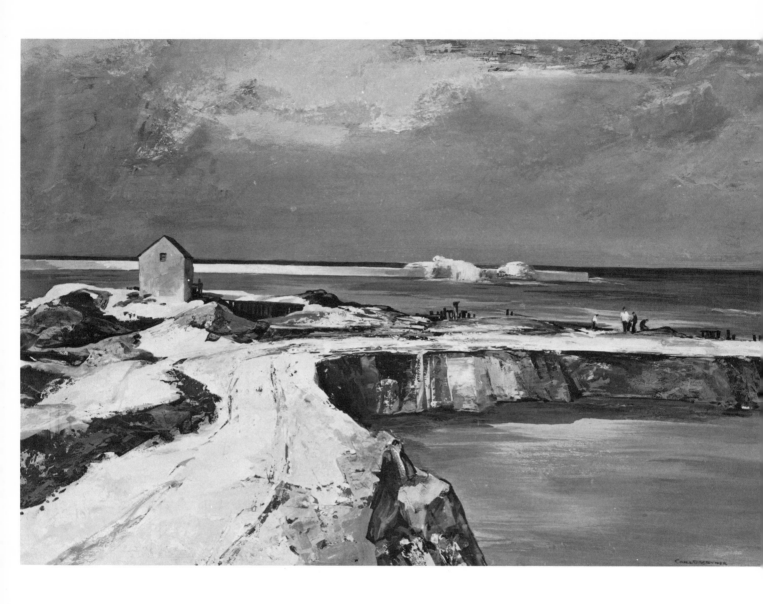

LAKE ERIE SHOREWAY by Carl Gaertner, gouache, 20½″ x 30½″.

A dark sky does not necessarily mean that the landscape below will be uniformly dark. The artist has introduced a break in the clouds, through which light flows downward to illuminate the roadway in the foreground. The light also breaks on a portion of the breakwater, which occurs just behind the single house. The water on the other hand, reflects the darkness of the sky, except for a few touches of reflected light. (Courtesy Metropolitan Museum of Art, New York)

Studies of Water

Clear reflections on still water, caused by objects resting on the landscape above, offer no difficulties to the painter, inasmuch as the artist has only to reverse the shape of the objects above onto the surface of the water below. This, combined with a few horizontal lines or streaks of color across the vertical reflections, creates a feeling of transparency in a picture. It is the easiest possible way of rendering water in a picture, but it is not so interesting as other problems in that direction. With all water studies, whether moving or tranquil, it is best to play for safety in the earlier stages of the sketch, keeping all the dark reflections fairly light and the light reflections fairly dark, thus helping to flatten the surface of the water, as well as create harmonious tones. Mature judgment is needed towards the completion of a sketch to decide how much or how little is required, to deepen or lighten the reflections in places.

WATER WITHOUT REFLECTIONS Then, again, certain lakes and rivers reflect very little of their adjoining surroundings. In some American and Canadian lakes, the general color is oftentimes an opaque, greenish blue, probably caused by alkali in the substance of the water. In water hurtling down from precipitous waterfalls, it is almost impossible to get a suggestion of any reflection whatsoever. Plate XL is a picture of a Canadian waterfall, the spray of the water, particularly in the lower part, creating so much foam that it has lost all transparent qualities. Even the rocks themselves are affected by this continual spraying of water. The shadows on the rocks at the foot of the picture are quite light in tone, since the surrounding light is reflected on their wet surfaces.

REFLECTIONS IN LIGHT AND SHADOW A very good example for demonstration purposes is the water study shown in Plate XXVII, entitled A *Venetian Canal*. This picture clearly displays the different effects of light and shadow on the same sheet of water. Water in shadow, if fairly transparent water, is capable of showing clear reflections. In

this instance, the reflections are easily seen in the top portion of the canal, which is in deep shadow, while all the foreground water is exposed to the glare of the sun. The brilliancy of the sun neutralizes the normal tone of the canal water, causing it to be lighter in tint, and making it impossible to reflect the dark toned buildings. The left side of the gondola throws its shadow on the water and prevents the sun from shining on this restricted area, with the result that a clear reflection is made visible.

The general color of this water is of a greenish blue tint. This tint is, of course, more noticeable in the shadow. At the same time, although the sun has such a strong effect on the water which happens to be exposed to its glare, even there the local color of the water is not entirely lost.

The following colors were used in solid flat patches for the groundwork or foundation of this picture.

Water in shadow: raw sienna, viridian and permanent blue, both mixed with a little zinc white.

Water in light: viridian mixed with zinc white, yellow ochre, and raw sienna.

Walls in shadow and dark figures, etc.: burnt sienna, permanent blue mixed with a little zinc white and deep purple.

Walls in light, bridge, and steps: warm gray (middle tint), and yellow ochre mixed with a little raw sienna.

Sky: deep blue mixed with a little permanent crimson.

The reproduction clearly shows the final colors used in this oil painting. Various colors occupying a small space, such as the rectangular wall immediately above the right hand side of the bridge, must be painted with definite touches and allowed to remain unmolested. If wrongly painted, the only way to remedy the defects is to scrape the colors off with the palette knife, without, of course, disturbing the foundation paint below.

Note the adjacent skeleton plan of *A Venetian Canal*. The dotted curve on the right, commencing from the bridge downwards, includes the miniature figures and boat at the foot of the building, finishing up with the figure of the gondolier, which slopes towards the bridge. The sweeping lines of the gondola connect up, as shown by the dotted line, with the vertical line of the building on the right, which adjoins the bridge.

SHALLOW WATER Plate XXIX is a pastel entitled *Bolton Abbey, Yorkshire*. Here we have quick running, shallow water, with the bed of the river showing in places through its surface. This is a very difficult problem for an artist. The tendency sometimes is to make the local color of the soil below the water too strong for practical purposes. That is to say, the reflecting glow from the bed of the river needs to be neutralized to a certain extent by an opaque suggestion of some grayish tint, whether warm or cold. In the first stage (Plate XXVIII), the local color of the soil was first laid on. The pastel was used sparingly so as to allow for the later tints. A positive color, such as pure red, is impossible in the finished picture, but pure red with a coat of gray over its surface gives that peculiar quality suggesting shallow water.

The student who has had no experience of pastel painting will find it

useful to copy the first and finished stages of this picture. The warm colors —red, brown, yellow, etc.—seen over the whole of the first stage are invaluable as a groundwork for the final touches of colder colors, such as gray, green, blue, etc.

The adjacent line drawing of *Bolton Abbey, Yorkshire* shows the leading compositional lines that connect the trees, which spread across the whole landscape.

The solid masonry of the abbey, with its horizontal and vertical lines, acts as a foil to the restlessness of the running water below. The clouds are in harmony with the abbey since they extend in the same horizontal direction.

MAKE LIGHTS DARKER AND DARKS LIGHTER

The watercolor entitled *The River Thames, Marlow*, although perhaps not scientifically accurate as regards water reflections, very faithfully carries out the suggestion (made at the beginning of this chapter) that the lights should be darker and darks should be lighter (Plate XXX). The reflection of the mansion in the water on the left side of the picture is darker as regards the color of the walls, and the reflection of the roof of the same building is lighter. Then again, the reflection of the dark mass of trees in the water on the right is obviously lighter. This feeling of unity on the whole surface of the water helps to suggest the necessary flat, horizontal plane of the river. It is too simple, when sketching out of doors, to forget this important fact.

This picture was painted in transparent color washes. The following foundation colors were used.

Sky: yellow ochre, light warm purple.

Dark trees: Hooker's green (middle tint), mixed with yellow ochre and very little light red.

Poplar trees: chrome yellow mixed with Hooker's green (middle tint).

Roofs of building: light red mixed with chrome yellow.

Water (right): a small quantity of ivory black mixed with permanent blue, with a little crimson, yellow ochre, and deep Hooker's green added in places.

Water (left): yellow ochre, warm gray, yellowish gray-green, and light warm purple.

Deep Hooker's green, deep purple, viridian, and touches of burnt sienna, together with bluish purple, were invaluable for the final painting of the dark toned trees. The sky and the water were completed in one wash, the colors being carefully mixed in advance. The tone of the paper can be seen in the sky, the lighter portion of the water, and the pathway in the foreground.

In the adjacent line diagram the dotted lines, suggesting the position of the cloudlets in the sky, demonstrate their harmonious relations to the landscape below. The two thin and tall poplar trees (on the left) contrast sharply with the circular formation of the heavier group of trees on the right.

The little flagstaff on the tower behind the mansion echoes the vertical direction of the poplar trees.

Figs. 37-40 are four drawings of reflections on water. Fig. 37 represents three poles and a stump. The horizontal dotted line represents the exact place where the water, if continued, would meet the poles. The thick, slightly curved horizontal line marks the place where the water meets the bank. The height of each pole above the dotted horizontal line is exactly the same as the distance of each pole below this line.

The illustration in Fig. 38 is of a tree trunk and two outbuildings. The circular drawing in the foreground represents the shape of a pond. The principle of reflection is precisely the same as in the first mentioned illustration (Fig. 37). The lower horizontal dotted line shows the junction of the tree trunk with the water if the surface of the water had been continued as far as this horizontal line. The higher horizontal line (below the more distant outbuildings) gives the height of the outbuildings above the height of the water. Here again, we must imagine that the flat plane of the water has been continued until it meets the junction of the buildings, which penetrate through the earth until they meet on the water plane. The reversed height of the building, then, is exactly the same below the higher horizontal line as above.

In Fig. 39, the illustration shows the drawing of a building, mountains, and some trees, with their reflections in the water. As the mountains are farther away than the buildings, etc., a second horizontal line was required to measure the heights of the mountains so as to get the same distance immediately below the higher horizontal line. It is interesting to note that the buildings, being nearer the edge of the water, are larger proportionally in their reflections than the taller mountains in the background. The mountain on the left, rising up behind the nearer mountain, should of course have another horizontal line to obtain more exact measurements, but sufficient has been shown to demonstrate that the perspective of reflections on water is not an exact science, although it is approximately correct.

The drawing in Fig. 40 is a naturalistic sketch of the reflection of a bridge, etc., on moving water. The other three drawings represent reflections on water which is motionless. The water in Fig. 39 shows a slight but perceptible ripple.

Fig. 37. Three poles, a stump, and their reflections.

Fig. 38. *Nearby tree trunk, two distant buildings, reflected in pond.*

Fig. 39. *Nearby buildings, distant mountains, and their reflections.*

Fig. 40. *Reflection of bridge in moving water.*

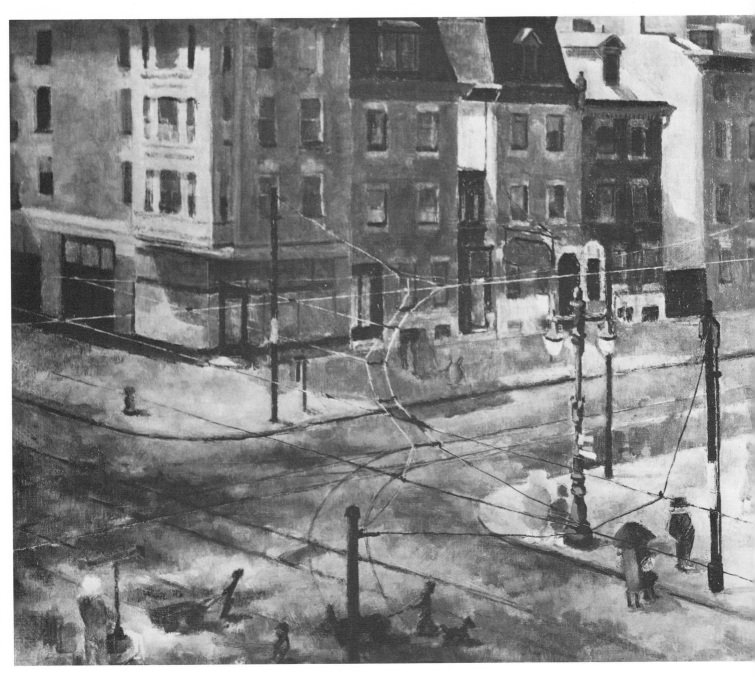

Intersection by Jeanne H. McLavy, oil.

The effectiveness of this cityscape is based, in part, on the unusual point of view taken by the painter. The street and nearby buildings are not seen from street level, but from above, as if the artist was looking from a second or third story window. This permits the painter to look down on the street and create an interesting pattern of the intersecting roadways, the curves of the trolley tracks, power lines, lamp posts, and other linear elements. Then, beyond this, the faces of the buildings create an interesting design of flat shapes in light and shadow. (Courtesy Pennsylvania Academy of Fine Arts, Philadelphia, Pennsylvania)

68

Studies of Buildings

The student who is able to paint still life objects should be well equipped for the study of buildings. They have the same thing in common in that they are stationary and least of all affected by passing events. On the other hand, a still life group in the studio, carefully arranged and left undisturbed, has the same effect each day under normal conditions, whereas buildings out of doors have a vastly different surrounding, and nature very rarely expresses the same color effect on two consecutive days.

PAINTING IN THE CITY Cities like London and New York offer fine opportunities for tone studies of buildings. These great cities suggest restrained color when compared with cities like Siena, Venice, Tunis, or Tangier. Moreover, at the approach of winter, when overcast weather and fogs have their own way, there are sometimes wonderful effects in tone, where positive color is almost eliminated, and the detailed sections of buildings are entirely lost. This provides excellent groundwork if the student already has the courage to paint out of doors.

Fortunate is the art student who has been through a course of practical architecture. Even a slight knowledge of architecture is of use to him when sketching palatial dwellings, particularly in Italy and in some parts of France and Spain. It is well known that many architects have successfully translated into terms of pictorial art buildings with which they are familiar as regards structure and detailed forms.

What might be described as artistic charm exists in old walls, with their various textures and colors. Too much attention to this sometimes is inclined to destroy the scale of a picture. On the other hand, the ability to express in a painting the texture as seen on old walls, etc., is not without its virtue. Oil and pastel are excellent materials for these textural surfaces.

OBSERVATION CAN LEAD YOU ASTRAY A general mistake some students make, in the early days of outdoor sketching of architectural subjects, is that sometimes their observation leads them astray. They notice that windows reflect light. This is perfectly true, yet the

fact is generally forgotten that, when painting the main wall of a house, particularly if the wall is dark in tone, with several windows in it, the student must first represent the flat plane or surface of the whole wall, irrespective of any light and shadow on its surface. There is a tendency to make the light reflected from windows much stronger than the natural effect. In such a case, when the sketch is taken home and seen under normal conditions, it is found that the lights reflected from the windows, by being painted too high in key, cause the windows to appear as if they were in front of the house, instead of on the surface of the wall. The best plan then, when light is reflected from windows, is to keep the tonality of the light darker than it actually appears to be.

ARCHITECTURAL
PAINTING IN OILS

The oil painting in Plate XXXI, *The Bridge Over Bruges Canal*, already described in Chapter 5, demonstrates the alternative possibility of showing brilliant lights reflecting from windows.

Here the face of the house immediately above the bridge, in the central portion of the picture, is in no way disturbed by light from the windows, because the whole of this building is almost as light in tone as the brightest light in the windows, thus giving the necessary flat surface.

In the first stage of this oil painting, the buildings, bridge, and water were well primed with touches of raw sienna, burnt sienna, deep chrome yellow, yellow ochre, and warm purple.

The tree, two figures, and the foreground on the left, received a preliminary coat of burnt umber, permanent blue, and a little permanent crimson mixed with burnt umber and burnt sienna.

For the sky, permanent blue, mixed with a little crimson and yellow ochre, was used. Notice how, in the final painting, the groundwork colors—particularly burnt sienna, deep chrome yellow, and yellow ochre—are allowed to show their existence in various parts of the picture.

The different brush marks of warm grays, etc., were mostly obtained accidentally through mixing odd colors left on the oil palette after a day's work. These color blends were then kept in a small zinc pan or dish filled with water to prevent the oil pigment from becoming hard, and held in readiness when required for this picture.

The green foliage of the tree and the circular reflection below the bridge and foreground, at the foot of the tree, were painted chiefly with viridian and a little terra verte, without losing sight of the rich toned groundwork below.

The principal interest in the adjacent diagram, apart from the general spacing of the tree and buildings, is the introduction of the two figures in the foreground, forming part of the general composition. They are enclosed in the curved dotted lines which extend upwards on either side and are continued along the contours of the tree until they reach the boundary lines enclosing the picture.

The general direction of the back and head of the seated figure, if continued as seen in the illustration, eventually touches the outer part of the lower building, finishing with the line of the roof above.

AVOID COLD
CHALKY COLOR

When making sketches of white structures or other buildings of light tones, especially in pastel or oil, there is nothing worse than a sketch where the

white walls look chalky and cold. (Notice also the remarks about snow painting in Chapter 10.) There is no definitely cold color in nature. A tinge of warmth is everywhere, since all light in daylight subjects comes from the sun. Shadows which reflect light therefore reflect warmth, and it is safer, when possible, to paint shadows with a slight suggestion of some warm pigment in their depths.

The easiest way to make a sketch of a white building in oil colors is to lay a foundation of small touches of yellow ochre, yellowish red, and gray. This must be done with thin pigment, leaving bare patches of the canvas in places so as to allow for the paint which follows. The next and final coat of paint must be pure white, mixed with a very little yellow ochre, and painted boldly over the wet surface below. The result should look almost like white paint, but not quite. It has just that subtle difference which makes the white part of the building rich with color, and yet consistent with natural effects.

The same remarks apply to pastel, and also to opaque watercolor.

For transparent watercolor, where no opaque color is used, the best plan (after dampening the paper) is to tint the white paper slightly with delicate yellow ochre and little touches of warm gray, slightly mingling one with the other. That should be sufficient to suggest a white wall bathed in sunlight.

Another way in which to paint the same wall in watercolor is to wash in equally distributed patches of yellow ochre, light crimson, viridian, and gray, the colors more or less touching one another on the surface of the white paper. While the surface is still somewhat wet, use a small sponge with pure water, and wash most of this color out with vigorous movements of the sponge. This will also suggest the effect of light on a white wall. Moreover, it is a very artistic way of expressing soft edges, and unexpected detail often appears, which in no way disturbs the serenity of a wall.

The watercolor entitled *The Fountain, Besançon, France* (Plate XXXII) is painted with the sky and the greater portion of the buildings in direct transparent washes. Practically the whole of the fountain in shadow is painted in thin running body color—transparent watercolor mixed with opaque white—allowing the natural color of the paper in places to give the correct value.

An undercoat of liquid yellow ochre was first painted, before there was added the slightly yellow tinted body color for the highlights extending downwards, on the left side of the fountain, onto the road and distant figures.

It is interesting to observe that not only do the three figures in the foreground give a sense of scale to the size of the fountain, but they also help, through their dark colors, to accentuate the tonality of the whole picture.

There is just enough dark blue sky in the top of the picture to help, through contrast of color, the atmosphere of warm and cool grays of the fountain, and also of the darker toned buildings behind. Only a small area is occupied by sunlight. Consequently, it was of importance, when spacing the position of the sunlight, to see that it made a good pattern.

Besançon, in France, has a good many subjects of buildings without too much detail. It also has excellent country of a distinctive character in the neighborhood. Some of the nearer villages have buildings showing the influence of Spanish architecture.

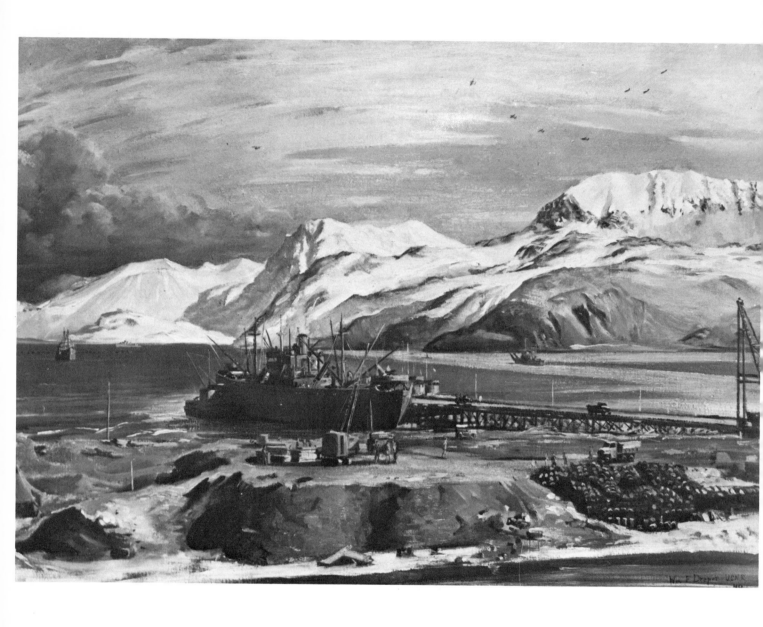

ADAK HARBOR by William F. Draper, oil.

Ships and harbors lend themselves to coastal landscapes with a lot of lively detail. In this panoramic view of a harbor with mountains, the light comes from above and slightly behind, illuminating the more distant mountains and throwing the nearer ones into shadow. The darkness of the sky heightens the effect of the snow on the mountains. On the water at the foot of the mountains, the artist has carefully observed the patterns of light and dark, which generally reflect channels, wind, and other natural phenomena which the beginning landscape painter should learn to recognize. Although the ship is the focal point of the painting, it is not allowed to dominate the surrounding landscape. Most of the ship is in shadow and it melts into the total atmosphere of the painting. It is interesting to watch how the painter adds a small touch like the flash of reflected light on the water at the stern of the ship, deftly separating the dark shape of the ship from the darkness of the water beyond. (Photograph courtesy American Artist)

Studies of Boats and Shipping

To draw boats, ordinary ships, and barges, is a genuine test of draughtsmanship. The foreshortening of a boat, when the front part is facing the spectator, necessitates obtaining exact proportion in a sketch. Before beginning a drawing of a barge seen in side view, the artist must also give very careful thought to the dimensions.

STUDYING BOATS The best way to acquire the necessary knowledge relating to boats is to draw those which are beached on the seashore, and likely to remain there for some considerable period. Then there is some opportunity of understanding the constructional meaning of a boat. It is advisable to draw boats in side view, three quarter view, end view, and in all the positions you can possibly conceive. After considerable practice of this type, one can tackle the same boats floating on the water. It is interesting to feel that a heavy piece of mechanism like a boat is floating easily on a soft, flexuous surface.

Sailing boats, when moving on the river or on the sea, require rapid observation on the part of the artist. Personally, I have often used a small brush, No. 3 or 4, with brown or greenish ink, and made rapid notes without any preliminary pencil drawing. If this is done on tinted paper, one not only gets a feeling of tone, but there is also a chance of getting a sensation of movement.

Some modern yachts are works of art apart from their sailing ability. It is marvelous to see them in a regatta, with their great sails spreading upwards, and displaying so much delicacy in color and swiftness in movement.

BARGES There is a curious solemnity about some of the barges on the canals near London, and the even larger barges on the river Seine in the neighborhood of Paris or on the Hudson River in New York. The fact that this type of barge has no tall, tapering masts to disturb the flat deck heightens the effect of solemnity. There is nothing to break up the noble formation of these low-lying river boats. At the close of day, when daylight is disappearing, the mas-

sive dignity of some of the Parisian barges becomes more noticeable through the elimination of detail lost in the evening shadows. An interesting aspect is created when the flexible and soft human figures of the barge's occupants are seen in contrast with the rigid structure of the woodwork, making fine pictorial matter for the landscape artist.

FISHING BOATS Students who are able to travel are earnestly advised to go to Chioggia, near Venice. It is about two hours' trip down the lagoon. There are three or four boats plying daily from Venice. On arriving at Chioggia, you will see an amazing spectacle of old fishing boats similar to those used in mediaeval times. Some of these boats have brass headed, hand chased bulwarks, showing a fine sense of form.

The sails represent the chief feature as regards color. When the boats are returning in the evening, bathed in the strong sunlight which is so noticeable on the Adriatic Sea, its brilliancy is reflected on the sails of these boats, some of which are bright orange in tint, with patches of emerald green where the sail has been repaired. Other sails have warm browns, relieved with patches of bright yellow, or any colored bits of sailcloth which happen to be handy in the sail yard when repairing torn or worn out sails. There are oftentimes drawings on the sails themselves, such as an olive wreath, or some Latin inscription. In years to come, these boats will entirely disappear. It is important to keep a pictorial record of them, since a faithful copy will in future times have historical value.

Some of the Chioggia boats look somewhat like the conventional schoolboys' pirate ships of fiction, where the boats have a rakish mast and a big, devastating sail. They are not quite so large, perhaps, as the boats described in juvenile stories, but they certainly are noble and fine in appearance. Incidentally, Chioggia, apart from the boats, is worth a prolonged visit for the study of old buildings. There is street after street of ancient houses, with curious arches, and people may be seen sitting out of doors mending nets, or engaged in making lacework from their own designs, and in other decorative homecraft.

The modern liner is not to be despised as an object of pictorial beauty in form and color. A good oil painting of one of the Atlantic liners should give as much aesthetic pleasure as the oldest boat at Chioggia. It is all a matter of personal interpretation.

GONDOLAS What can be more dainty or charming than the gondolas of Venice? They are so superbly constructed that they appear almost to be out of the water, so lightly do they touch the surface. The vitality of the gondola is almost uncanny. It springs and bobs and leaps at the least irritation caused in the water. Very few artists have been able to translate successfully the spirit of these boats in their sketches or pictures. Accurate drawing seems almost fatal in conveying the truth. The lively spirit of the subject does not seem compatible with sound drawing. Possibly the best way to tackle the movement of a gondola in a picture is not to draw it conventionally, but with a few rapid touches of a brush to suggest the general mass of the gondola.

Plate XXXIII is the first stage of a picture entitled *Boats at Gravesend*. This was done on tinted paper, the color of which is clearly noticeable, and drawn carefully as regards the nearer boats. The distant sailing boat was sketched in quickly at sight. After the pencil work was finished, all of the drawing was strengthened with a small brush and waterproof brown ink. This gave a feeling of security before any color washes were used.

The finished picture (Plate XXXIV) needs little description. It is merely transparent watercolor used to tint the previous ink drawing. Notice should be taken of the depth of the color in the farther sailing boat, since its richness of tone in the darker sails helps to suggest the feeling of a luminous background. This is a faithful representation of an actual scene off Gravesend. The patchwork on the smaller sail on the right of the picture prevents the sail from looking too opaque in color. Little touches of variety keep pictures from appearing commonplace.

The chief colors used for the sails were burnt sienna and light red—warm gray for the sky and water—vandyke brown, purple, and delicate green for the woodwork of the boats. It had to be borne in mind that the natural color of the paper had a neutralizing effect on *all* these colors.

It is interesting to note that Gravesend, which is so easily reached from London, is quite unspoilt so far by the effects of modern life like similar towns in Maine. The town has many old buildings, narrow streets, and alley ways. There are always varied types of craft on the water, while occasionally a big liner steams slowly down the middle of the Thames on its way to the sea, causing the everyday boats and ships to look very small in contrast.

The river Mersey at Liverpool has many sailing craft worth sketching. Cornwall is famous for its fishing boats, whilst Whitby, in Yorkshire, attracts numbers of artists. Similar subject matter can be found in America—on the New England coast or the San Francisco bay area, for example.

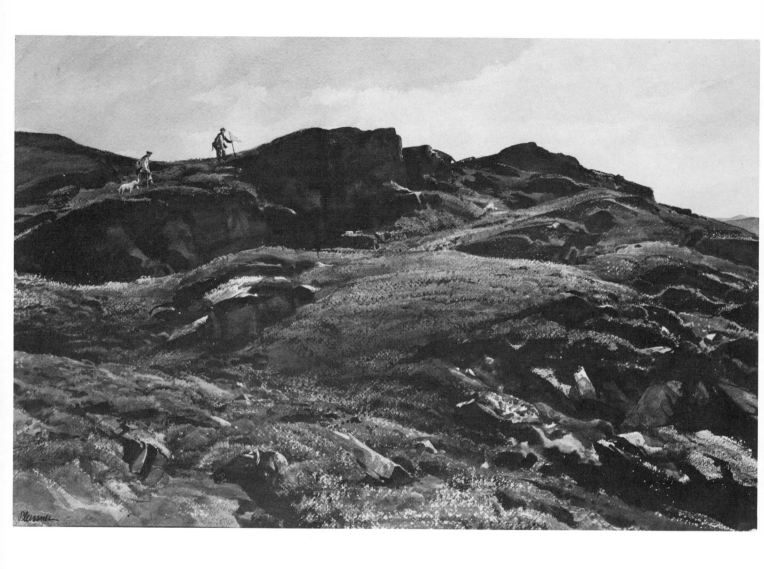

A Perthshire Moor by Ogden M. Pleissner, watercolor.

Painted at a time of day when the light comes from behind, the rock formation is almost entirely in shadow, with just a few touches of light along the upper edge. The same is true of the foreground rocks, which are simply touched here and there with a fleck of light. This kind of lighting is particularly important when painting rock formations and mountains, which need a clear definition of light and shadow planes. The figures not only establish the focal point of the composition, but also lend scale; without them, it would be impossible to determine the size of the rock formation. (Photograph courtesy American Artist)

Undulating Landscapes

Undulating landscapes suggest a certain amount of charm in landscape art. Such a subject dissipates the thought of anything relating to a powerful, or characteristic, mountain scene. It is the antithesis of everything which is not harmonious. What is usually meant by undulating landscape is subjects consisting of hills and valleys, with their flowing curves meeting each other at harmonious angles, thus suggesting the method of construction underlying this type of picture.

The Sussex Downs in England, the rolling green landscapes of Vermont and Pennsylvania afford good examples of undulating landscapes. The simple line work of curves in Figs. 3 and 4, Chapter 3, displays the elementary stage of flowing curves. In some places there are truly delightful pastoral scenes, where intersecting or tangential curves play an important part. Any monotony that might have been caused through an overdose of harmonious lines in these landscapes is avoided through the contrast of groups of trees, sharply intersecting fields, and sometimes even farmhouses and barns.

UNDULATING HILLS Plate XLVIII, entitled *The Brendon Hills, from Williton, Somerset,* shows a good example of undulating hills clothed with intersecting lines of fields, groups of trees, etc. The distant hills in this picture have the same constructional basis as the middle exercises in Figs. 3 and 4. Notice how the fields take up less space as they recede towards the high horizon.

UNDULATING FOREGROUND, MIDDLE DISTANCE AND DISTANCE Plate XXXV is a full page color illustration, entitled *Château de Polignac, France.* This picture displays undulation in the immediate foreground at the foot of the pastel painting, and the middle distance, as well as in the flowing distant hills. To help the composition, the ascending line of the fields, at the foot of the hill below the château, converges upwards from the right, center and left side respectively, thus leading the eye towards the château itself, and concentrating on the most important part of the picture: the Château de Polignac.

The upright trees in the foreground, spaced chiefly on the right, act as a contrasting factor to the fields spreading horizontally between the château hill and the foreground. The vertical tower of the château and the smaller spire (lower in the picture) on the left, echo the upright direction of the foreground trees.

The lower part of the picture is dark in tone, and as the château and adjoining buildings are also dark, it is important that the lower portion of the picture should be strong enough in tone to support the heavy portions above.

To give full value to the flowing, distant hills, the sky is painted very nearly flat, and any clouds that are introduced are on such a small scale that they do not interfere with (or render irritating) the general appearance of the picture. There is a good deal of chatter and detail shown in the little rectangular fields in the middle distance, hence the value of a comparatively flat sky, so that the spectator's attention shall be diverted to the points of interest shown in the middle distance.

<div style="display:flex"><div style="font-style:italic;width:30%">COLOR AND DESIGN</div><div style="width:70%">

The color of the paper—a warm gray—is more noticeable at the foot of the picture, particularly towards the right. The preliminary pastel colors were laid on in the same manner as in the first stage of the picture seen in Plate XXVIII.

It cannot be emphasized too often that all pastel pictures, irrespective of the subject matter, must first receive on the tinted paper a loosely handled groundwork of dark and warm colors, so as to give a solid foundation, on which can be placed touches of lighter and sometimes colder colors.

For this picture, the following pastel colors were used as the foundation.

Sky: yellow ochre, light warm gray.

Distant hills: yellow ochre; Prussian blue.

Château, dark hills, and foreground: burnt sienna, deep violet, and dark warm brown.

Patchwork fields, etc.: chiefly burnt sienna and yellow ochre.

Light Prussian blue was worked over and between the sky colors mentioned above, with cream white shade for the cloudlets, to complete the sky in the final stage.

All the above colors are much influenced and modified in strength through the tone of the paper on which they were used. In the diagram adjacent to Plate XXXV, a happy contrast is shown. The straight lines of the château produce a sensation of security when seen in company with so many undulating curves. The trees on the right also demonstrate the principle of contrast, which is so important in picture designing.
</div></div>

<div style="display:flex"><div style="font-style:italic;width:30%">CLOUDS IN UNDULATING LANDSCAPES</div><div style="width:70%">

Cumulus clouds can often be used to advantage in this type of landscape. The rolling forms of undulation can be echoed in the cloud shapes peculiar to the cumulus formation.

The dignity of shape generally associated with cumulus clouds is also in harmony with the movement of the landscape below. Long, thin clouds, horizontally inclined with a slight curvature, are quite adaptable to this style of landscape; while one or two cloudlets at the top of the picture, in a large, simple, and flatlooking sky, create a feeling of serenity.
</div></div>

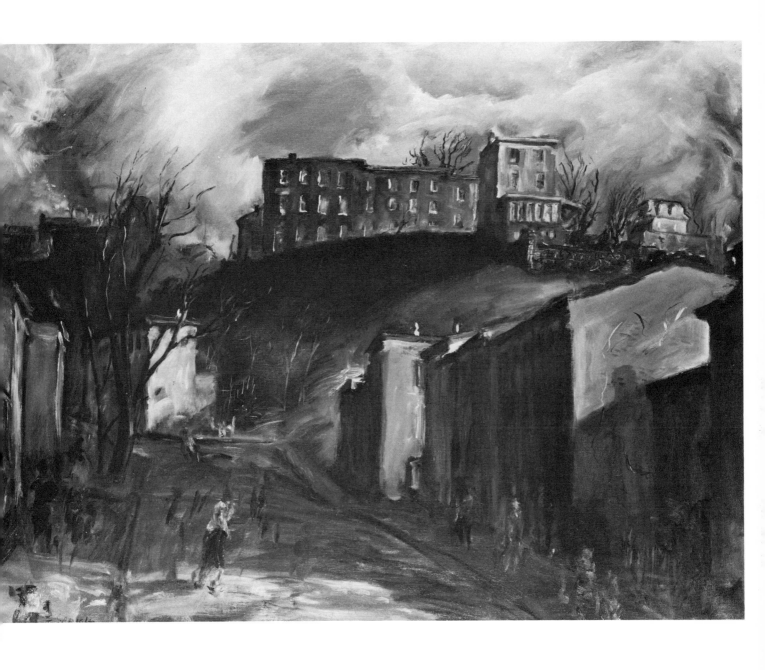

HILLS OF MANAYUNK by Francis Speight, oil.

Here is an interesting use of perspective. The buildings are on two levels and those on the lower level recede to a vanishing point which indicates that the horizon is just one third of the way up from the bottom of the picture. However, above this horizon rises a hill which is crowned by another cluster of buildings, all of which are well above eye level. The effect is to give loftiness to the hill and to the buildings on it. Observe how the stormy sky swirls around the buildings on the top of the hill, with each patch of light and dark methodically placed to direct attention to the center of interest. Such casual brushwork is always more carefully planned than the viewer might suppose. (Photograph courtesy American Artist)

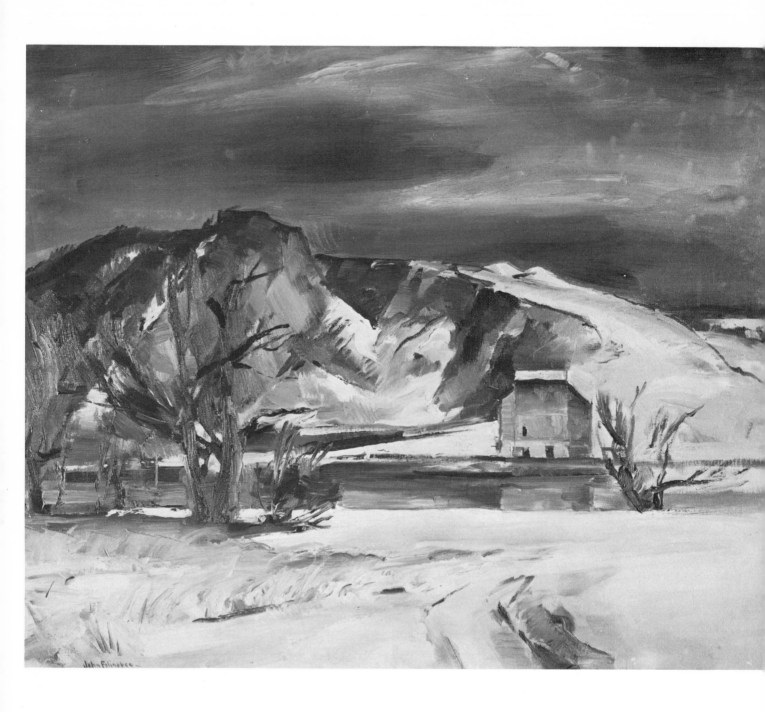

MERCER QUARRY by John Folinsbee, oil.

Free, spontaneous brushwork is not an end in itself, but must reflect the forms that the artist is painting. The bold, lively brushwork in this landscape is carefully planned to express the nature of the landscape itself. In the sky, for example, the broad, blurry strokes interpret the direction of the cloud. Along the sides of the quarry, the strokes follow the changes in direction of the light and dark planes. The trees are interpreted in jagged strokes that communicate the movement of the trunks and limbs. And even the distant house is painted in flat, geometric strokes. (Photograph courtesy American Artist)

Plate I. Four basic tones for foreground, middle distance, distance, sky. Every detail of this watercolor must be right density. Picture would fail if any portion of landscape appeared to be in wrong spatial plane because of incorrect value.

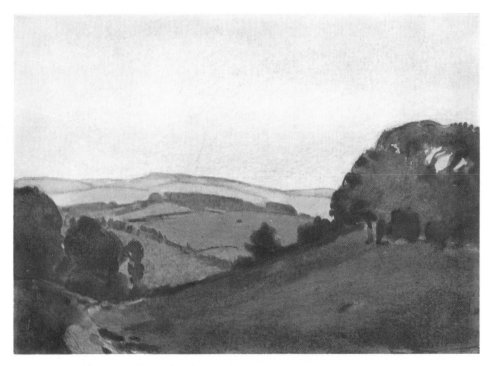

Plate II. Same landscape, in washes of full color, again places all elements in correct spatial plane by establishing four values for foreground, middle distance, distance, sky.

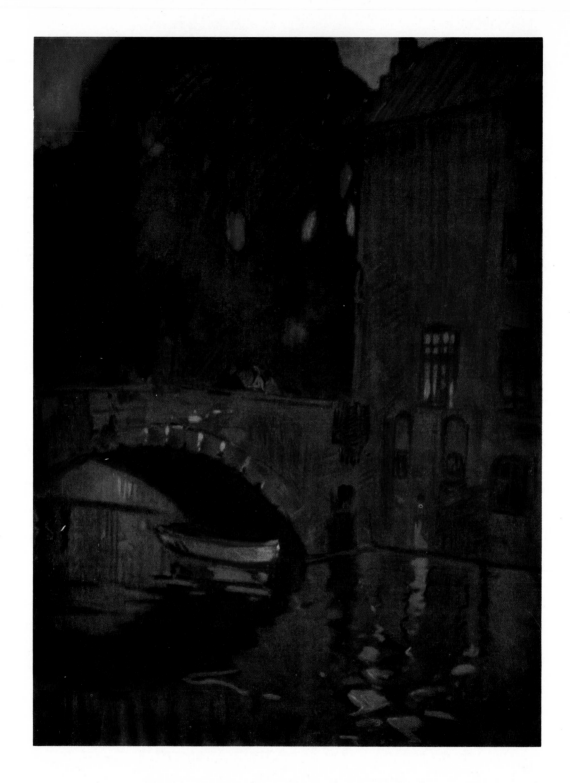

Plate III. A Gray Day at Bruges, *pastel. This was a difficult subject because artist had no definite lights or shadows to work from; without positive light, careful observation was needed to convey correct values. If small color notes, like figures on bridge or boat beneath, were too light, unity would be disrupted. Every color on water had to be just right to keep surface one continuous plane. Unity is maintained through restraint. It is nearly always safer to do too little than too much.*

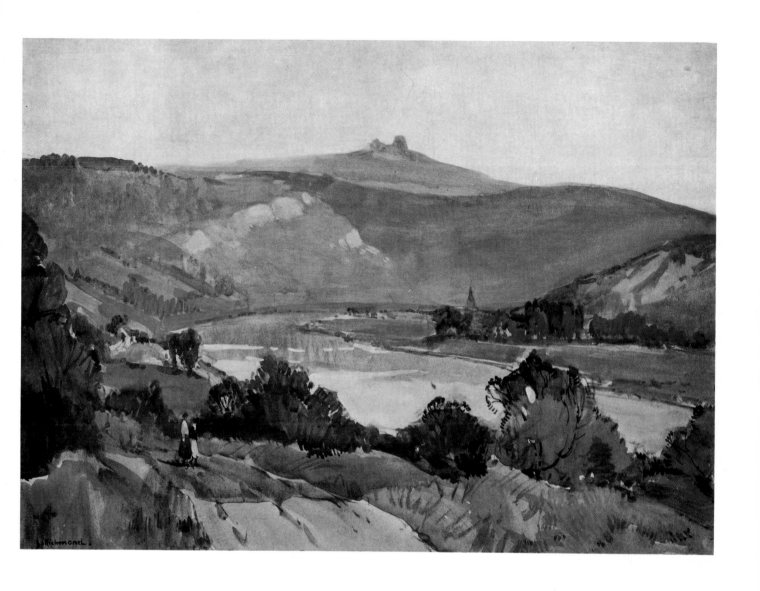

Plate IV. THE RIVER DOUBS, BESANCON, FRANCE, *watercolor. Very light groundwork of sky was mixture of yellow ochre, cerulean blue, opaque white (body color). Sky tint was painted down to water's edge; while this color was still wet, hills were painted in with flat brush. Hill details were painted into wet color. River contains some opaque white, but rest of foreground is transparent. Bushes toward right are strengthened with sharp touches of dark violet.*

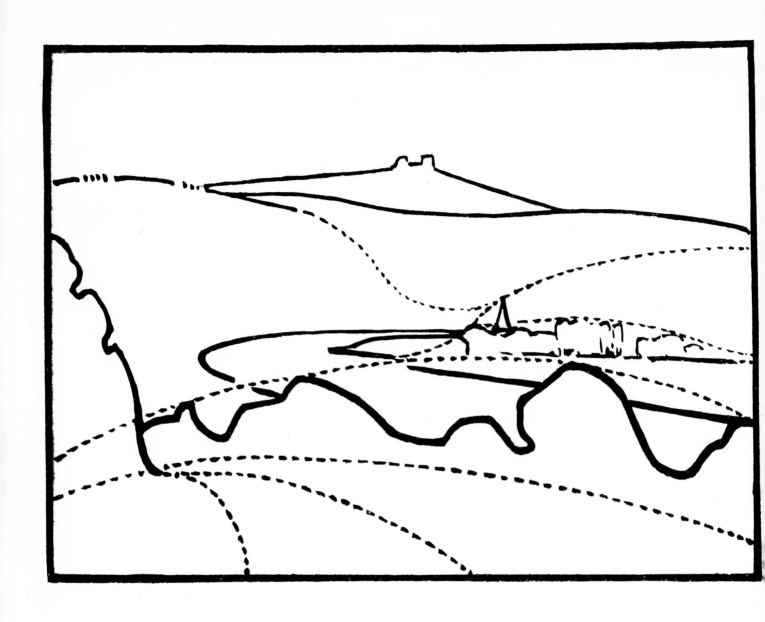

Analytical diagram of Plate IV shows lines of river connecting foreground with middle distance and extending to foot of distant hills. Dotted curves explain composition; notice how dotted curve, sweeping across river, carries rhythm of middle distance into foreground.

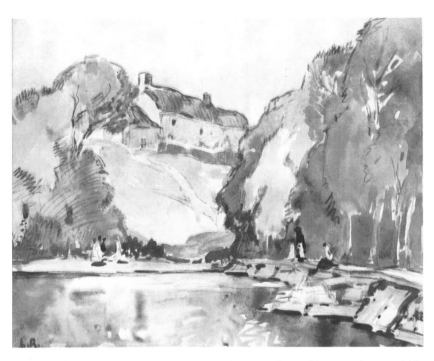

Plate V. *Rapid watercolor note was done in about thirteen minutes, without striving for actual facts of nature. Simplicity of coloring is result of lack of time—just flat, running washes, partly mingling, with paper sparkling through here and there. Such sparkle is difficult to obtain in more finished studio picture which has been painted over with two or three washes.*

Plate VI. *Pencil sketch on ordinary writing paper, with watercolor tints. Pencil lines are still noticeable. Colors were used merely to tint and suggest tonality without strong lights or deep shadows.*

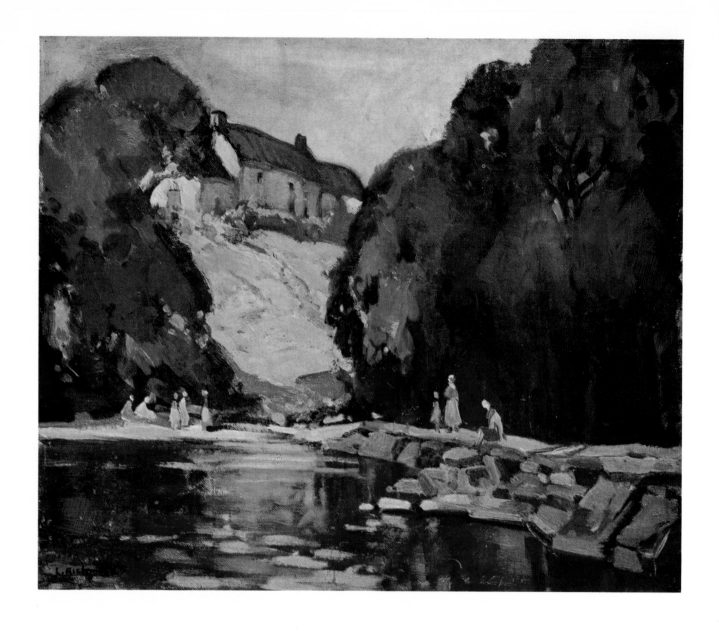

Plate VII. Tor Steps, Exmoor, Somerset, *oil painting, shows how full scale painting can evolve from simple sketch like Plate VI. Here we get tonalities of nature—deep greens, dark water, deep colors of rooftops, sombre effect of heavy foliage—in contrast to luminous transparency of little watercolor. Groundwork colors (later modified by overpainting) were yellow ochre, cerulean blue, light purple in sky; burnt umber, burnt sienna, viridian, deep purple in trees, rooftops; burnt sienna, purple, burnt umber, raw sienna, yellow ochre in water; warm gray and grayish purple in hill and stone bridge. All colors were applied flat in early stage and kept apart from one another; only in final stage were colors blended, dragged over one another to produce mixtures, broken color effects.*

Plate VIII. A Minehead Cottage, Somerset, *first stage of watercolor.
From the very beginning, all border lines of cottage and contours of tree
were kept scrupulously in place.*

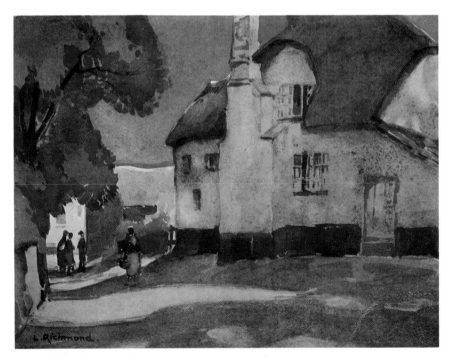

Plate IX. A Minehead Cottage, Somerset, *final stage of watercolor.
Final colors were carefully contained within precise preliminary design.
Same subject could have been drawn more freely, with more vigorous color
and deeper tones, for very different effect.*

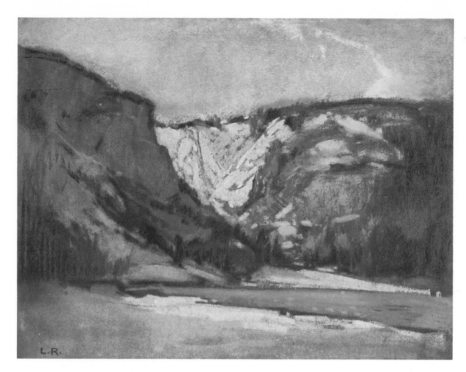

Plate X. Pastel sketch, preliminary study for watercolor in Plate XVI. Compare strength of pastel with suggestiveness of watercolor sketch in Plate XI.

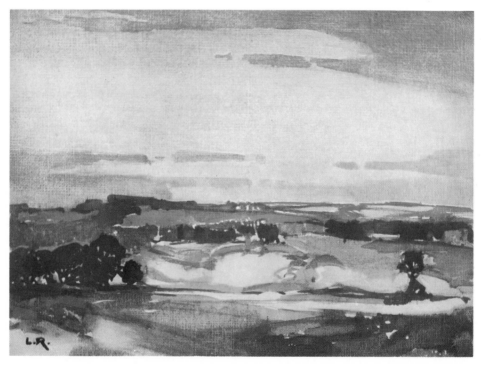

Plate XI. Watercolor sketch emphasizes design. Horizontal feeling of upper and lower clouds harmonizes with and reflects horizontal spacing of landscape below.

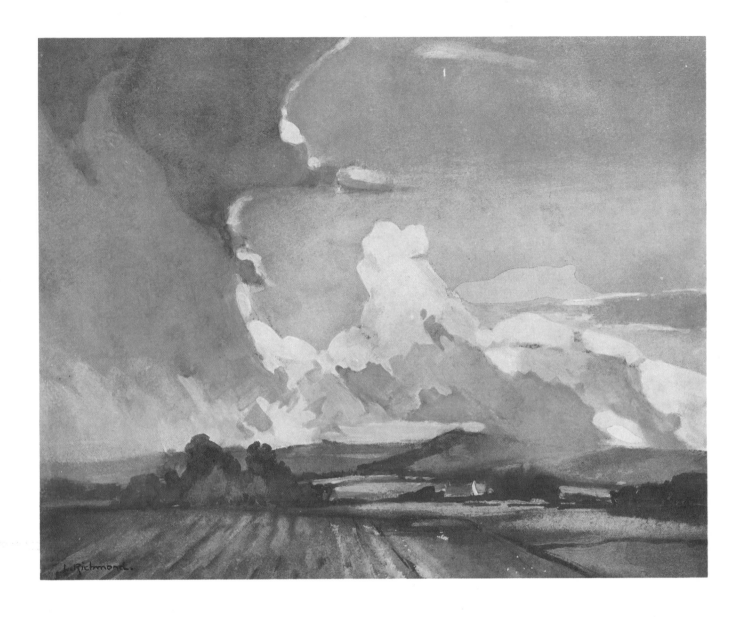

Plate XII. STUDY OF MOVING CLOUDS, *watercolor. Design helps illusion of movement: larger cloud on top left swings downward toward right to connect up clouds near horizon and dark hills with adjoining landscape below. Colors used included a good deal of body color (opaque white): gray-blue, yellow ochre, a little crimson mixed with some opaque white in sky; permanent blue (mixed with a little permanent crimson) and warm gray in hills; Hooker's green (middle tint and deep) mixed with burnt sienna in trees; yellow ochre and raw sienna in foreground, laid on in transparent washes. Cloud tints immediately above hills were carried over parts of hills while still wet.*

Plate XIII. Gradated watercolor wash is deepish blue at top, becoming lighter and changing color as it moves downward. Paper was tilted slightly to allow colors to blend naturally.

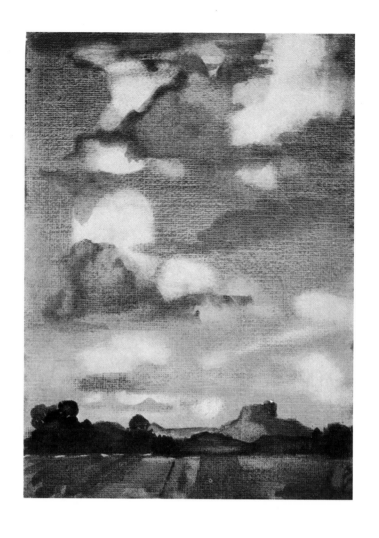

Plate XIV. Watercolor sky was done in same manner, but clouds were washed out with small sponge. Note that clouds become smaller as they near horizon, suggesting aerial perspective.

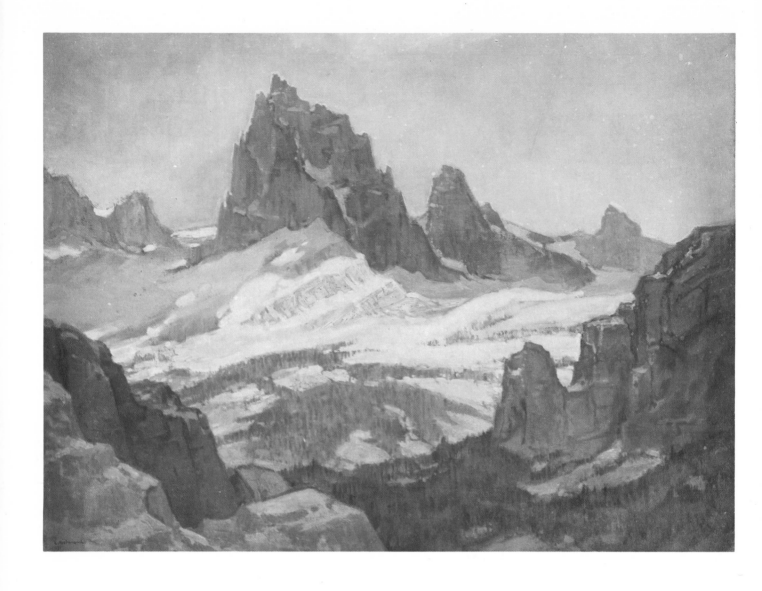

Plate XV. Cathedral Mountains, Canadian Rockies, *oil painting.
Basic colors used in foundation stage were: yellow ochre, warm gray, cobalt
blue, zinc white, viridian in sky; raw umber, raw sienna, cobalt blue, per-
manent crimson, burnt sienna, terre verte, zinc white in distant mountains;
yellow ochre and zinc white in snow; dark warm gray and purple in snow
in shadow; burnt umber, burnt sienna, deep purple, dark warm gray in
foreground mountains. Greenish tint of ice was first painted with yellow
ochre and white.*

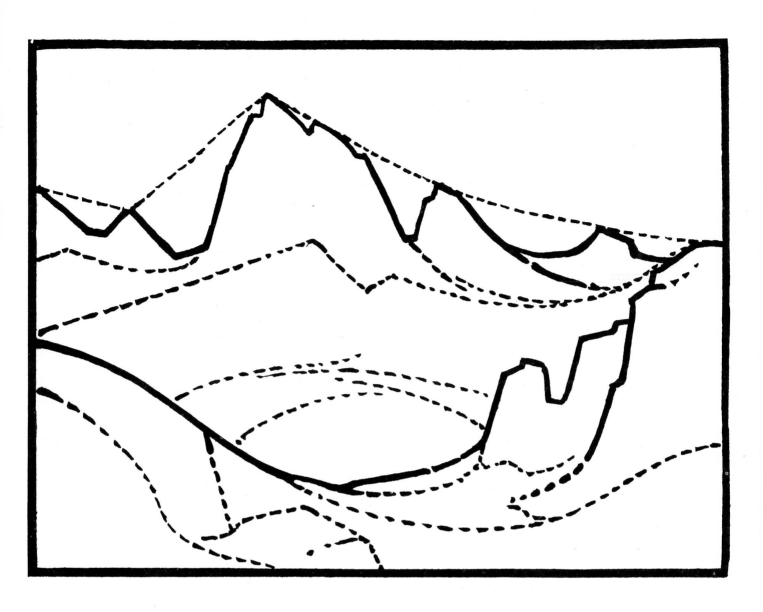

Analytical diagram of Plate XV shows unity of design despite angular forms. Topmost peaks are bound together in dotted marginal line which extends in outward (convex) direction. Lower masses of rock formation at foot of picture show opposite effect, extending in inward (concave) direction.

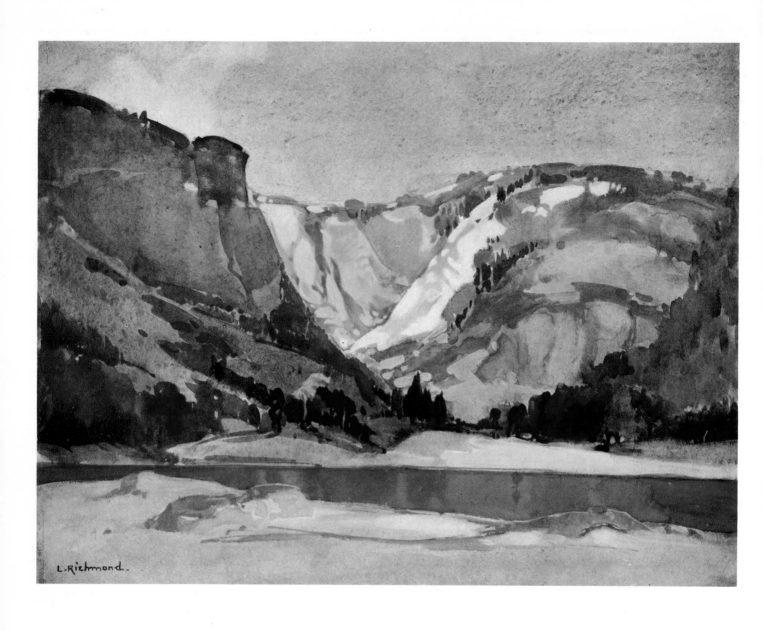

Plate XVI. A DECORATION, *watercolor, based on pastel sketch in Plate X. Groundwork colors were: ultramarine blue, well diluted with water, for sky; purple (cobalt blue and permanent crimson), yellow ochre, burnt sienna in dark hill; yellow ochre and warm gray, painted on damp paper, in light hill and foreground; cobalt blue and viridian in water. In final stages, highlights were painted with thick opaque white, mixed with yellow ochre, etc. Darker toned trees were painted two or three times over to get rich tones.*

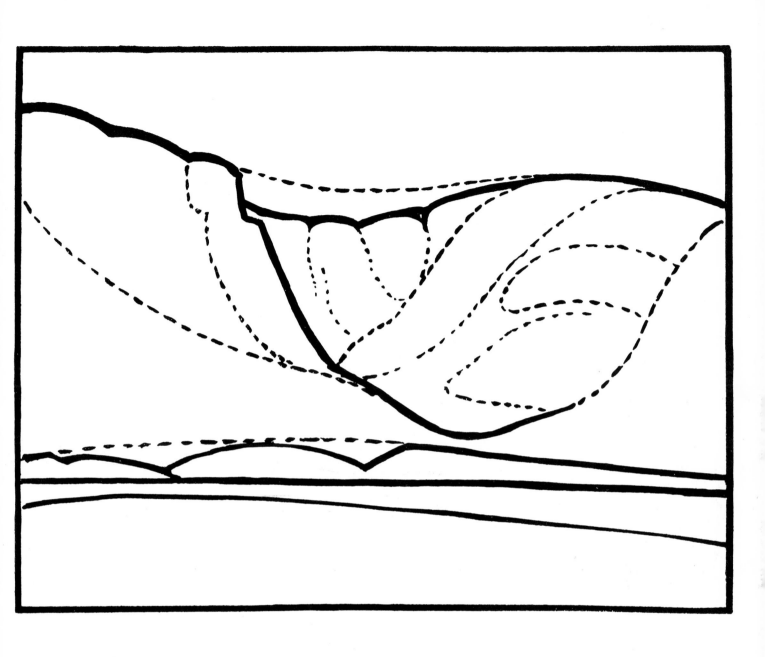

Analytical diagram of Plate XVI show harmonious curves supported by straight horizontal line extending across lower portion.

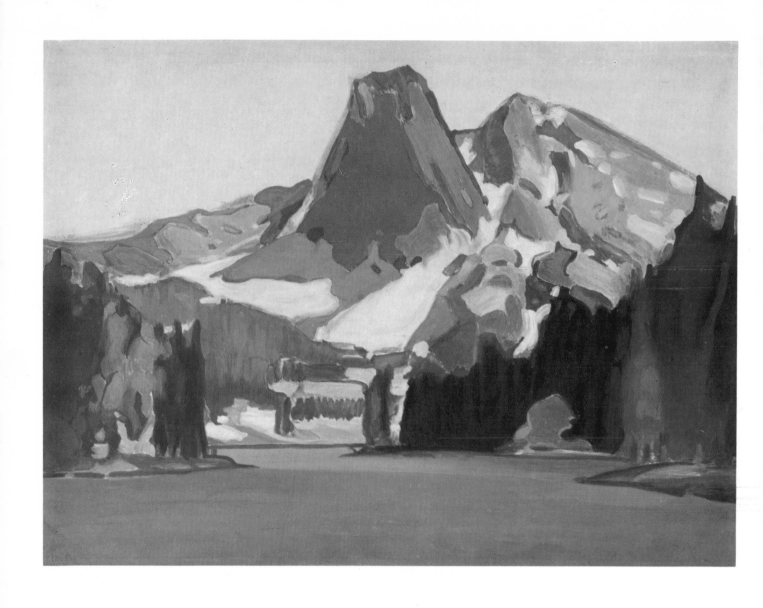

Plate XVII. Emerald Lake, Canadian Rockies, *first stage of oil painting. General design is first blocked in with decisive flat tones, with practically all colors kept darker than those in finished picture (Plate XVIII). Remember that snow colors need warm underpainting of yellow ochre and white so that final, lighter coat echoes some of warm color beneath. White snow, painted directly on raw canvas, looks dry and chalky.*

96

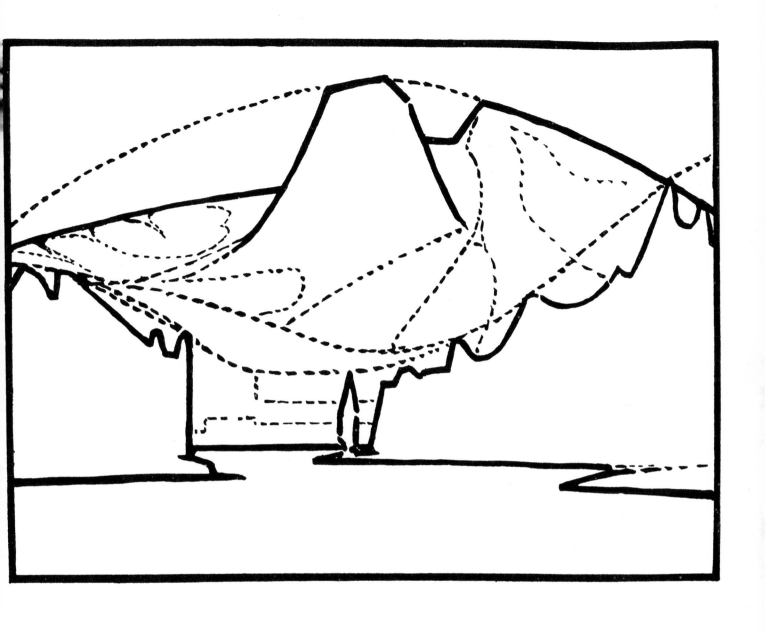

Analytical diagram of Plate XVII follows same convex-concave principle shown in Plate XV. Tops of mountains (dotted lines) demonstrate convexity; central portion demonstrates concavity. Rigid horizontal lines (below) support great weight of mountains.

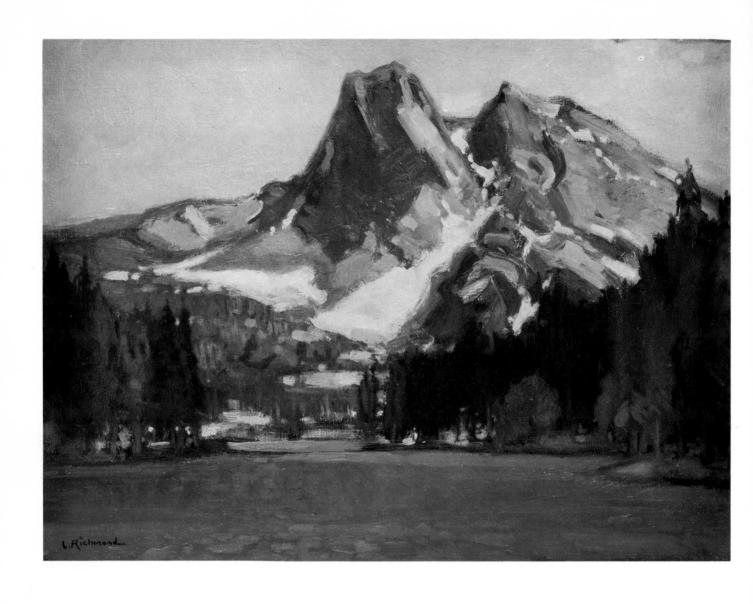

Plate XVIII. EMERALD LAKE, CANADIAN ROCKIES, *final stage of oil painting. Finished picture shows addition of lighter tones, painted generally over mountains and snow, while trees received more detail, and surface of water is more luminous and broken. Flat tones of first stage are now animated by rough brushwork.*

Plate XIX. Watercolor study of mass foliage, first stage, is painted in flat tints, with minimum detail and only slight tonal variation.

Plate XX. Watercolor study of mass foliage, final stage, shows addition of strongly defined shadows of deep color. Some detail is suggested, but handling is still broad.

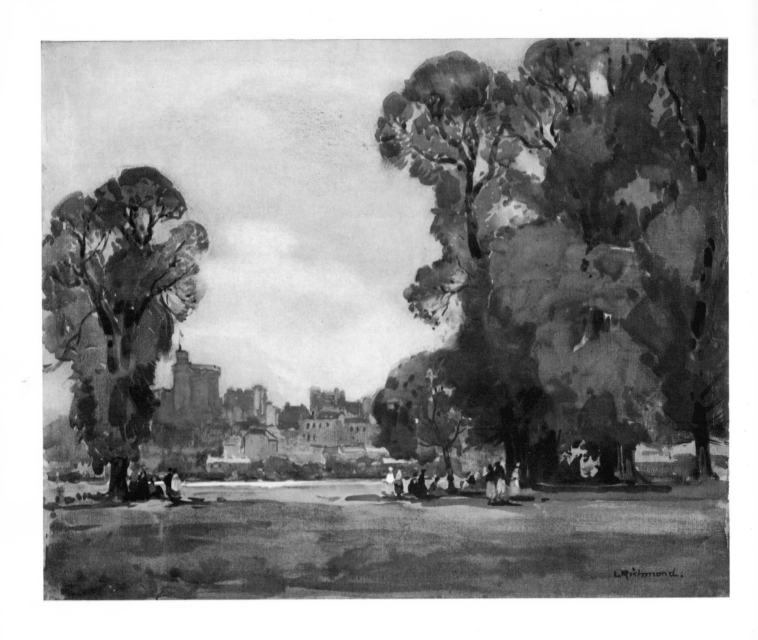

Plate XXI. Elm Trees at Windsor, *watercolor. Try copying trees in this picture, following same principles of flat painting demonstrated in Plates XIX and XX, adding dark shadows and suggestions of detail in final stage. Foundation colors were: yellow ochre and ultramarine blue in sky; deep Hooker's green, yellow ochre, purple, permanent blue in trees; yellow ochre mixed with light gray, light purple mixed with yellow ochre, vermilion mixed with light gray in distant buildings; Hooker's green (medium) and burnt sienna in foreground. Lower portion of sky was wiped out with small sponge; contours of tall trees received same treatment to prevent hard edges.*

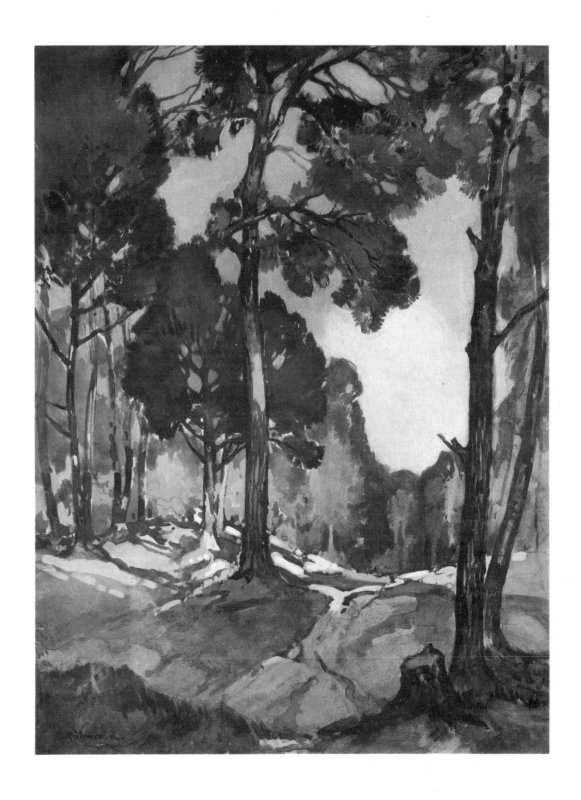

Plate XXII. Fir Trees, Pas-de-Calais, France, *watercolor, was begun with pure washes of transparent color. In the final stage, body color (opaque white) was used for the sky and for certain portions of the foliage and foreground.*

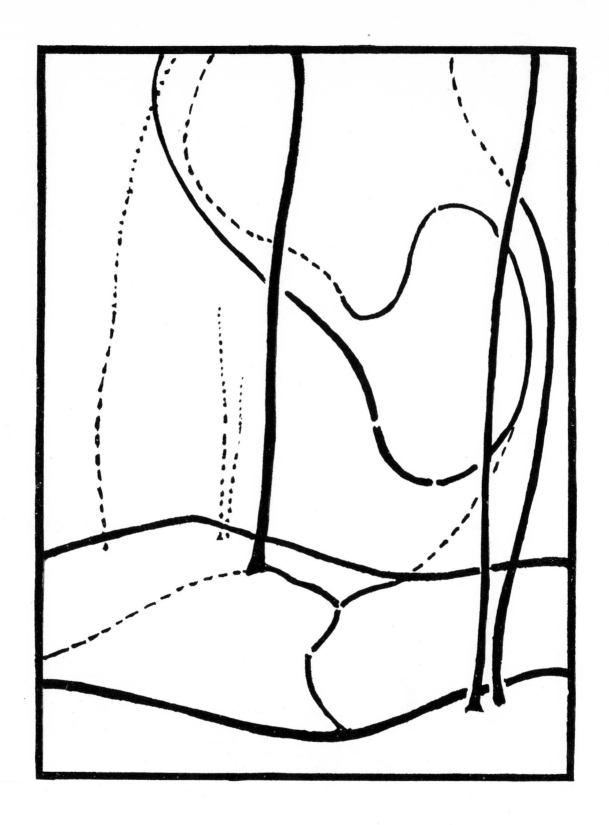

Analytical diagram of Plate XXII emphasizes sky opening on right, which is oval and travels upwards to higher left side. Vertical trunks cut sharply across sky opening. Winding pathway is harmoniously related to constructional lines above.

Plate XXIII (left). Watercolor study of foliage detail, first stage, is just flat wash indicating branches and mass of leaves.

Plate XXIV (right). Watercolor study of foliage detail, final stage, shows darker tints added before first wash was quite dry.

Plate XXV (left). Watercolor study of fir followed same method, beginning with flat tones, then adding shadows and detail.

Plate XXVI (right). Watercolor study of chestnut leaves follows careful pencil outline; detailed form was sought for, unlike preceding plates.

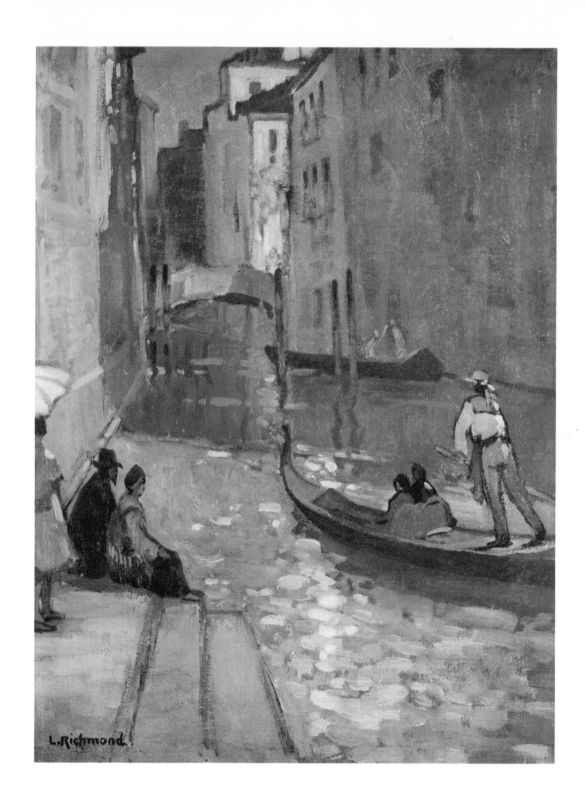

Plate XXVII. A VENETIAN CANAL, *oil painting. This study clearly displays different effects of light and shadow on same sheet of water. Reflections appear in top portion of water, in shadow, while brilliant sun neutralizes normal tone of foreground water, making reflections of dark toned buildings impossible.*

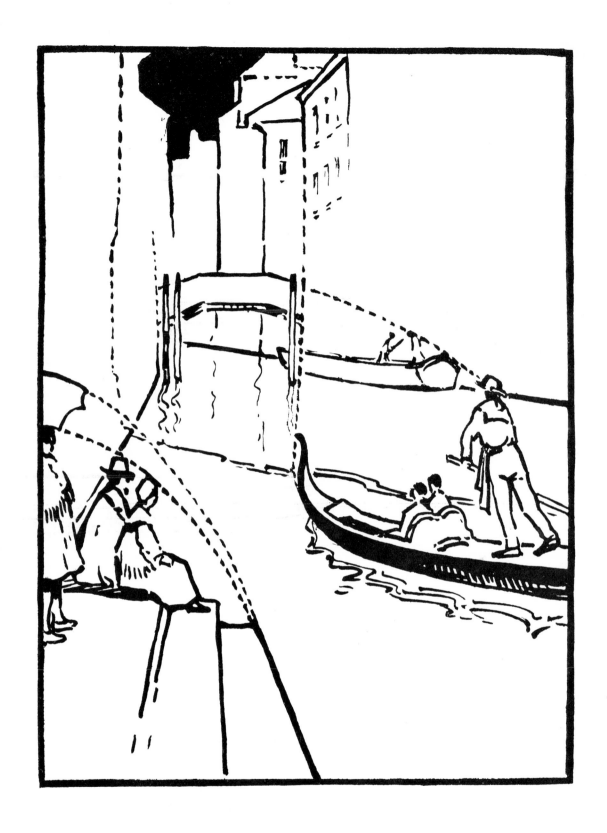

Analytical diagram of Plate XXVII. Dotted curve on right encompasses bridge, miniature figure and boat at foot of building, figure of gondolier. Sweeping lines of gondola connect with vertical line of building on right, which adjoins bridge.

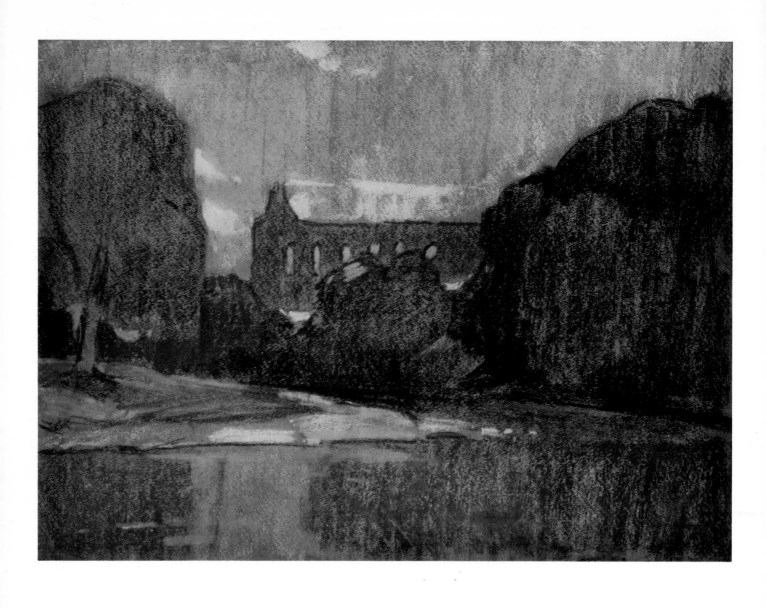

Plate XXVIII. Bolton Abbey, Yorkshire, *first stage of pastel. Quick running, shallow water, with bed of river showing in places through surface, is very difficult problem. Warm glow from river bed needs to be neutralized to some extent by opaque suggestion of grayish tint. In first stage, warm local color of soil was first laid on; pastel was used sparingly to allow for later tints.*

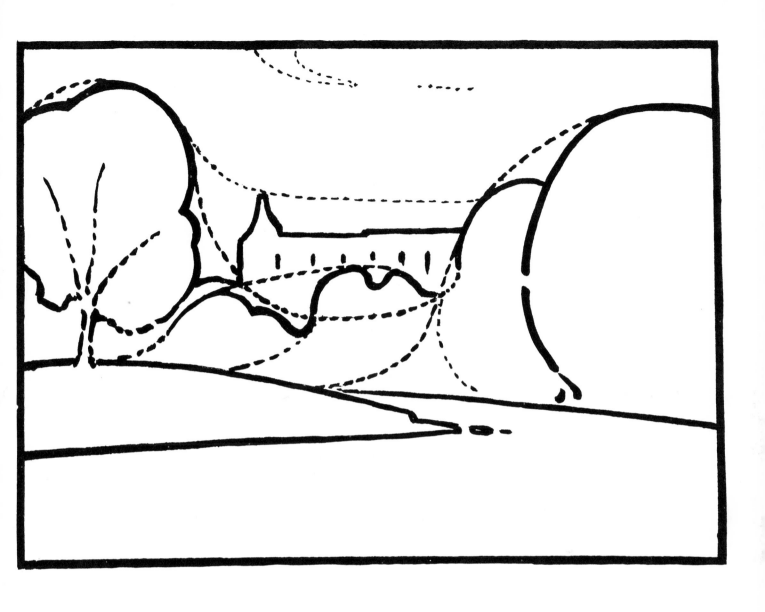

Analytical diagram of Plate XXVIII shows leading compositional lines that connect trees, which spread across whole landscape. Horizontal and vertical lines of abbey act as foil to restlessness of water below. Horizontal clouds harmonize with direction of abbey.

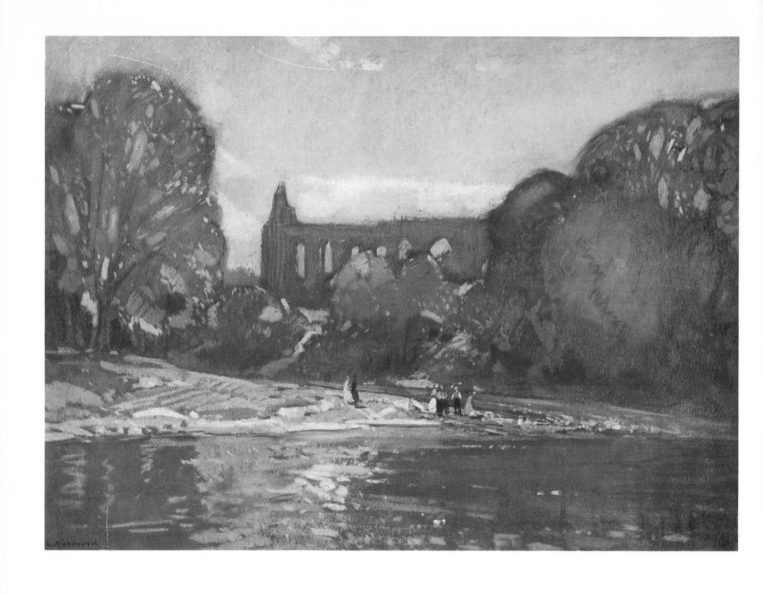

Plate XXIX. Bolton Abbey, Yorkshire, *final stage of pastel. Warm colors in first stage—red, brown, yellow, etc.—form invaluable ground-work for final touches of colder colors, such as gray, green, blue, through which warm colors are reflected. Student will find it useful to copy first and final stages of this pastel.*

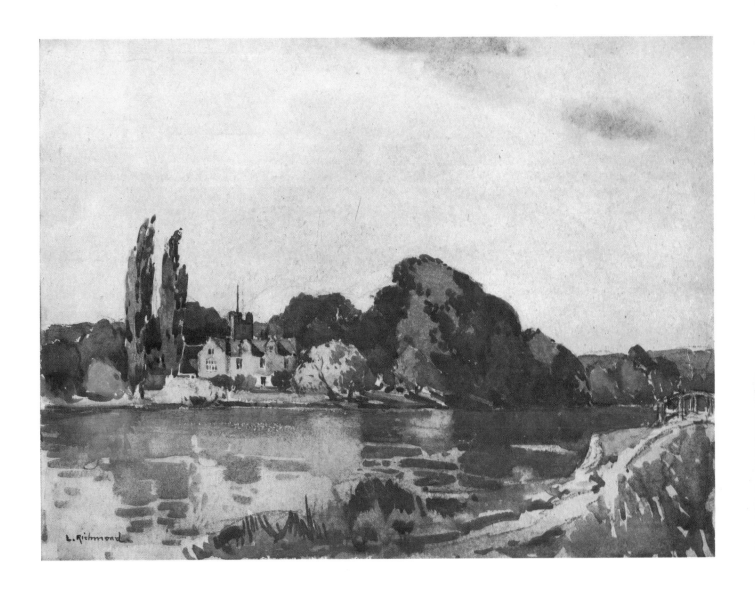

Plate XXX. THE RIVER THAMES, MARLOW, *watercolor, follows recommendation, made in text, that lights should be kept darker than in nature, while darks should be kept lighter. Reflection of mansion (in water at left) is darker than color of walls, while reflection of roof is lighter. Reflection of dark mass of trees is lighter. Purpose of this subtle distortion is to maintain unity of flat, horizontal plane of water. Foundation colors were: yellow ochre, light warm purple in sky; Hooker's green medium, yellow ochre, light red in dark trees; chrome yellow and Hooker's green medium in poplar trees; light red and chrome yellow in roofs; ivory black, permanent blue, crimson, yellow ochre, deep Hooker's green in water at right; yellow ochre, warm gray, yellowish gray-green, light warm purple in water at left.*

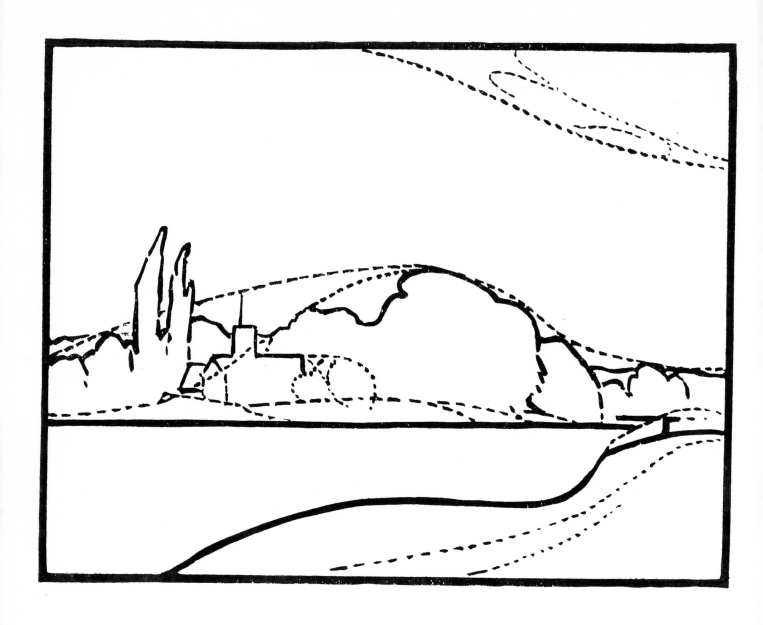

Analytical diagram of Plate XXX. Dotted lines, suggesting position of cloudlets in sky, demonstrate hormonious relations to landscape below. Thin, tall poplars (left) contrast sharply with circular formation of heavier group of trees on right. Little flagstaff on tower behind mansion echoes vertical direction of poplars.

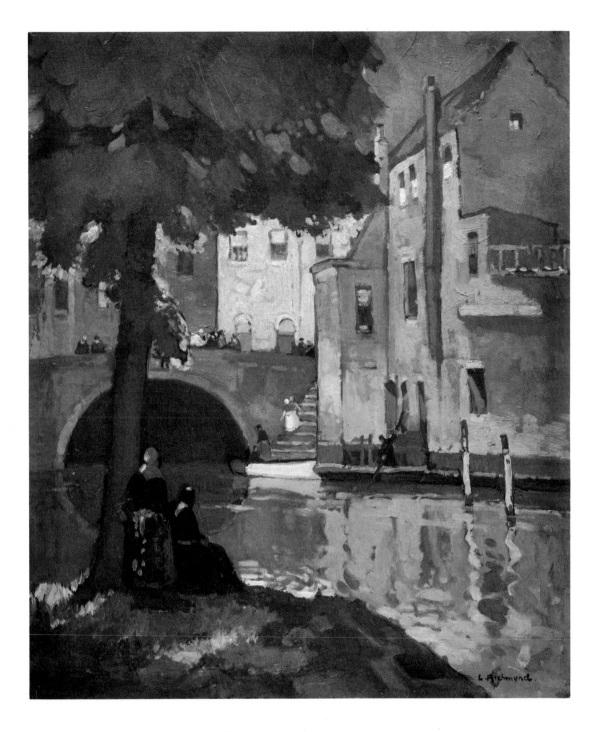

Plate XXXI. The Bridge over Bruges Canal, *oil painting. In first stage, buildings, bridge, and water were well primed with touches of raw sienna, burnt sienna, deep chrome yellow, yellow ochre, warm purple. Tree, two figures, foreground on left received perliminary coat of burnt umber, permanent blue, permanent crimson mixed with burnt umber and burnt sienna. For sky, permanent blue was mixed with a little crimson and yellow ochre. Various grays were obtained by mixing odd colors left on palette after day's work. Note how, in final stage, green foliage of tree and circular reflection below bridge (painted chiefly with viridian and a little terre verte) still show rich, warm undertones from first stage.*

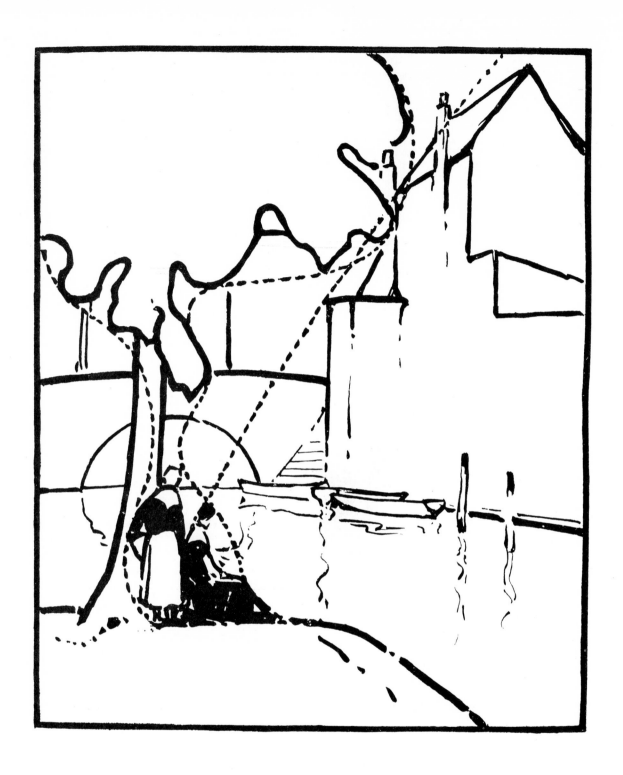

Analytical diagram of Plate XXXI shows how two figures in left foreground form part of composition. They are enclosed in curved dotted lines which extend upwards on either side and interlock with other elements of design.

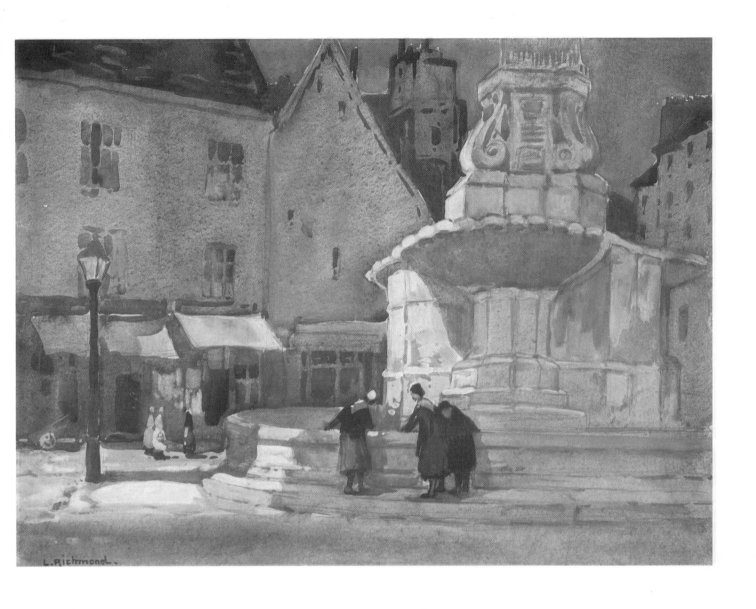

Plate XXXII. THE FOUNTAIN, BESANCON, FRANCE, *watercolor. Sky and greater portion of buildings were painted in direct, transparent washes. Practically whole fountain was painted in thin, running body color—transparent watercolor mixed with a little opaque white—allowing natural color of paper to come through in places. Undercoat of yellow ochre was painted before yellow tinted body color was added for highlights on left of fountain and road. Note that only small area is occupied by sunlight; remainder is in shadow. Three small, dark figures give sense of scale and accentuate tonality of whole picture.*

Plate XXXIII. BOATS AT GRAVESEND, *first stage of watercolor. Painted on tinted paper, the color of which is clearly noticeable, this watercolor began with pencil sketch, which was then strengthened with waterproof brown ink, applied with small brush. This gave feeling of security before any color washes were added.*

Plate XXXIV. Boats at Gravesend, *final stage of watercolor. Here transparent watercolor was used to tint ink drawing in Plate XXXIII. Note depth of color in farther sailing boat; richness of tone in darker sails helps to suggest feeling of luminous background. Patchwork on smaller sail to right prevents sail from looking too opaque in color. Little touches of variety keep pictures from appearing too commonplace.*

Plate XXXV. CHATEAU DE POLIGNAC, FRANCE, *pastel, displays undulation in immediate foreground, middle distance, as well as flowing distant hills. Lower part of picture is dark to support heavy portions above. Sky is painted nearly flat to give full value to hills and to detail in middle distance. Foundation pastel colors, underlying final colors, were: yellow ochre, light warm gray in sky; yellow ochre and Prussian blue in hills; burnt sienna, deep violet, dark warm brown in chateau, dark hills, foreground; chiefly burnt sienna, yellow ochre in patchwork fields. Light Prussian blue was worked over and between sky colors mentioned above, with creamy white for cloudlets. All colors are modified by warm gray tone of paper.*

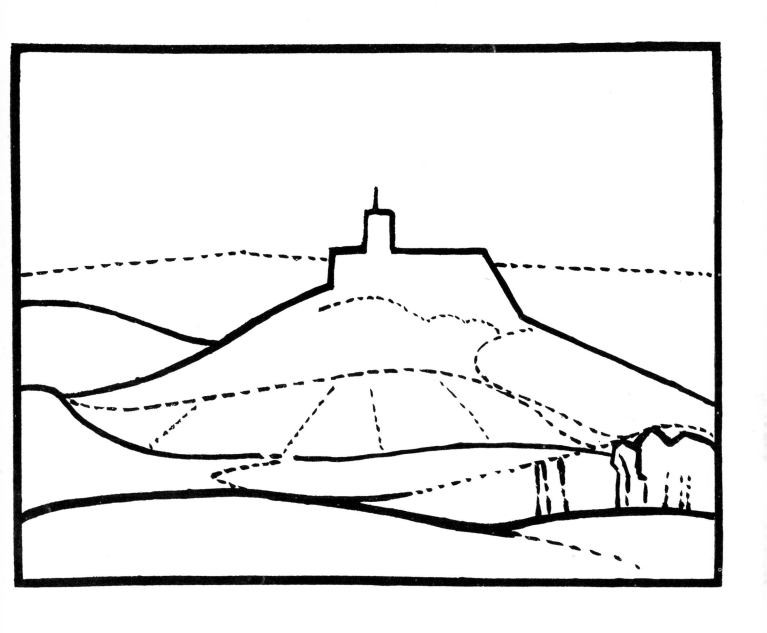

Analytical diagram of Plate XXXV. Ascending line of fields from right and left leads eye towards chateau. Upright trees in foreground act as contrasting factor to fields which spread horizontally. Vertical tower and spire echo upright direction of trees.

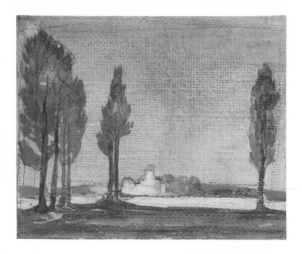
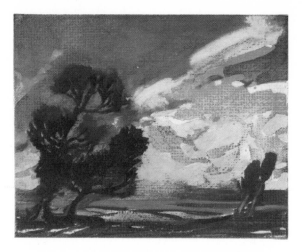

Plate XXXVI (left). Tranquility, *watercolor. Mood is obtained by severe upright parallel lines of trees, rising at right angles to flat ground; absence of flamboyant curves or tonal contrast.*

Plate XXXVII (right). Storm, *watercolor. Sketching storms must be done from memory, for obvious reasons. Note how direction of clouds and trees reflects violent mood.*

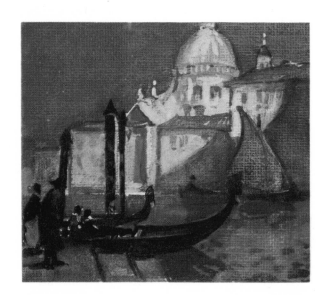
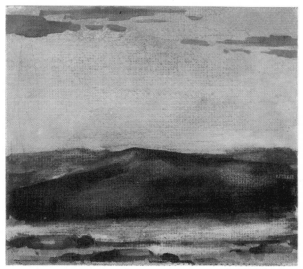

Plate XXXVIII (left). Moonlight, *watercolor. Luminous warm tones and sombre cool colors reflect glamor of night.*

Plate XXXIX (right). Evening, *watercolor, expresses calm of declining day in general horizontal design; large empty space of sky; rich, yet restrained color.*

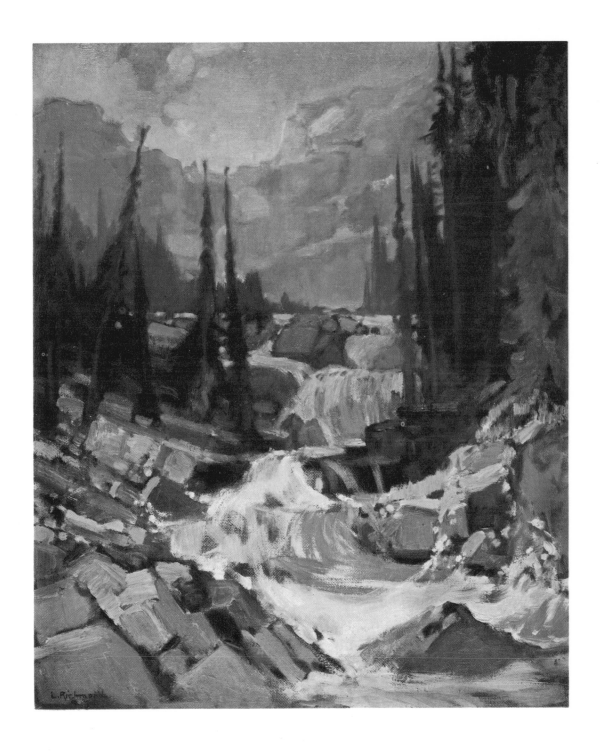

Plate XL. A CANADIAN WATERFALL, *oil painting, reflects violent mood of nature. Foundation colors, later modified by succeeding colors and brushwork, were: warm gray interspaced with patches of yellow ochre, bluish purple in sky; dark warm gray, bluish purple, terre verte mixed with yellow ochre in mountains; permanent blue mixed with purplish gray in distant trees; burnt umber, ivory black, raw umber, permanent blue in nearer trees; burnt sienna, yellow ochre, purple, silver gray in rocks; yellow ochre, warm gray mixed with viridian, light reddish purple in water.*

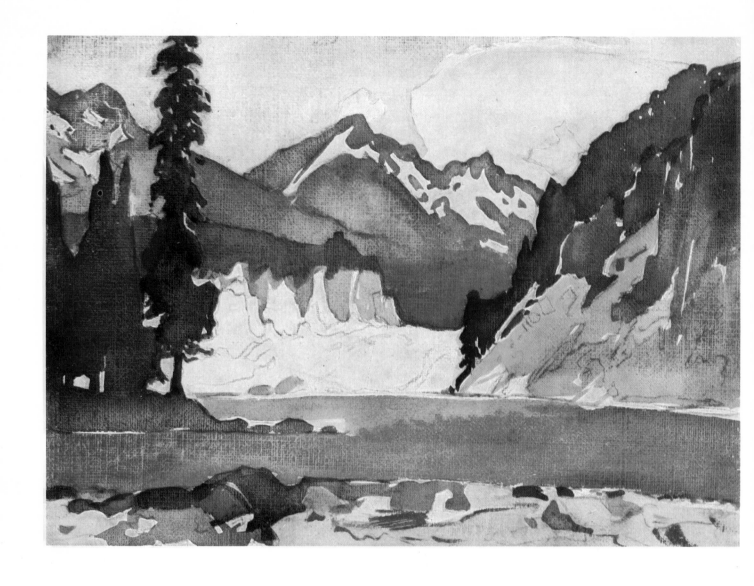

Plate XLI. Bow Falls, Baniff, Canadian Rockies, *first stage of water-color. Trees were so dark and sinister that artist had to exaggerate tones to convey powerful effect of lowering clouds, dark trees, light foam of falls. First stage shows some of preliminary pencil drawing, particularly in light area at center. Picture was painted entirely in transparent watercolor, without aid of opaque color (body color), on canvas grained paper.*

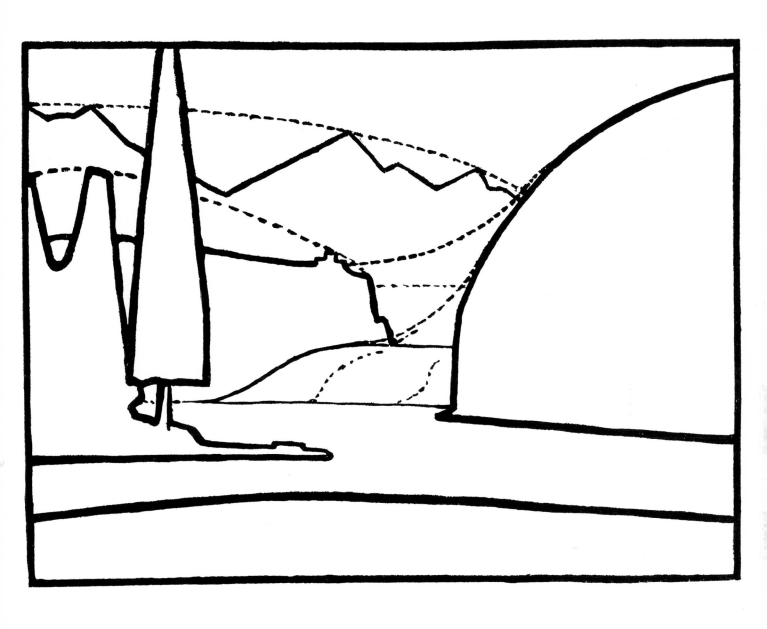

Analytical diagram of Plate XLI. Strength of horizontal lines in lower portion of picture contrasts with jagged contours above. Apex of each mountain touches dotted curve.

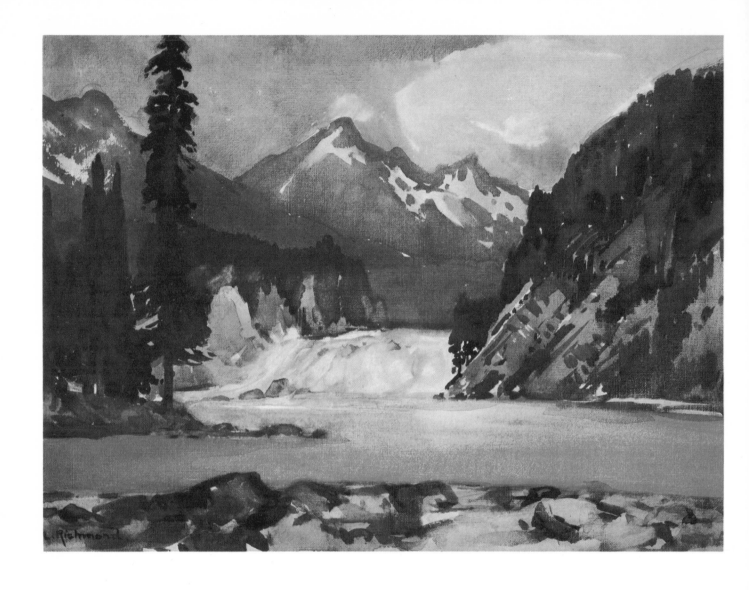

Plate XLII. Bow Falls, Banff, Canadian Rockies, *final stage of watercolor. Compare with Plate XLI. In final stage, deep shadows were added, trees were darkened, and detail shown where needed. Whole sky and distant mountains were united by one flat wash of light yellowish gray. In watercolor, it is nearly always essential—when no body color is used—to wash transparent light tint over portions of colored groundwork to unite and solidify whole scheme.*

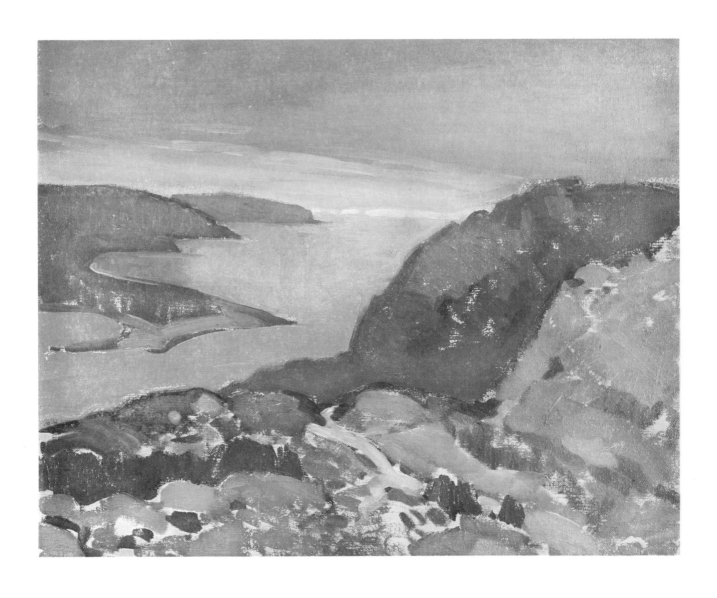

Plate XLIII. THE ESTUARY, BARMOUTH, NORTH WALES, *first stage of oil painting. Drab, quiet, melancholy day is difficult subject for artist to paint. Contrast is low, strong sunlight is absent, and sky is nearly as dark as distant hills. In first stage, colors were painted in fairly bright tints, somewhat flat, to enliven overlying colors.*

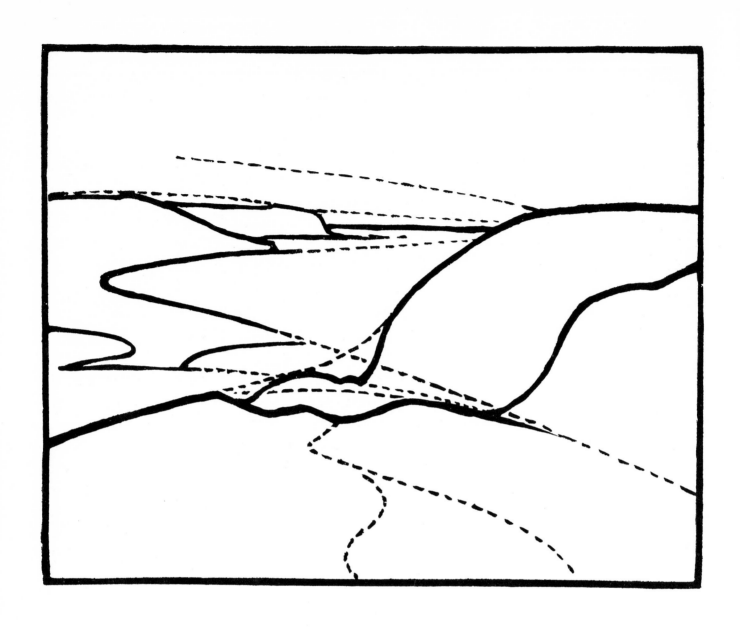

Analytical diagram of Plate XLIII. Horizontal line of sea is placed two thirds of distance up from bottom line. Coast lines (see dotted lines) connect with foreground construction.

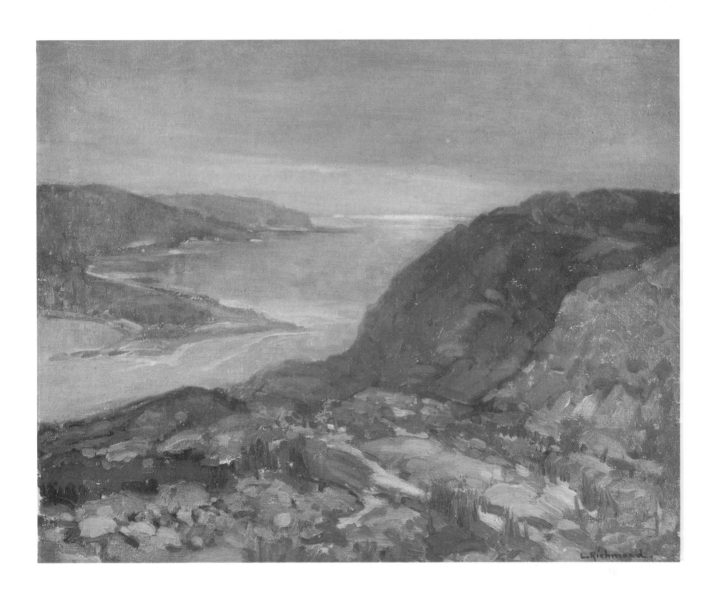

Plate XLIV. THE ESTUARY, BARMOUTH, NORTH WALES, *final stage of oil painting. Completed picture retains subdued quality of nature's mood. Colors are far less intense, more muted, but more varied than groundwork colors in first stage. Yet underlying colors lend vitality.*

Plate XLV. The Watchet Coast, Somerset, *oil sketch. When sketching in oils, paint vigorously with strong brushstrokes. Do not hesitate to make mistakes—they may suggest something—but paint decisively, get strong sense of tone and color.*

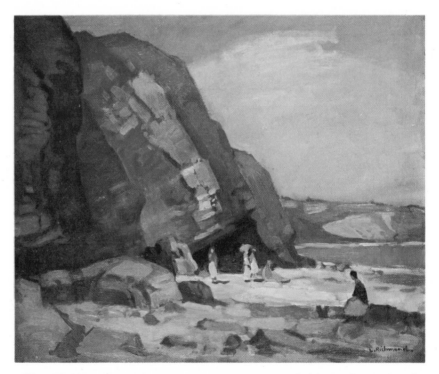

Plate XLVI. The Watchet Coast, Somerset, *finished oil painting. In final picture, sky has lost cold, grayish blue; rocks show more form and better drawing; slight color changes establish better tone relationships.*

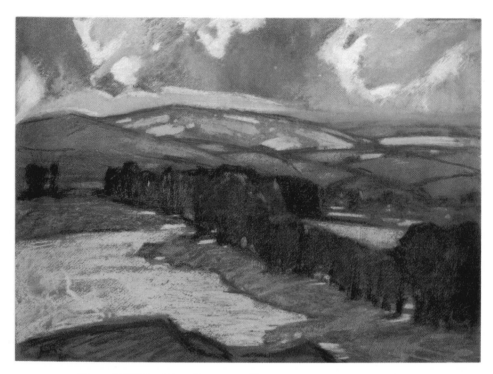

Plate XLVII. The Brendon Hills from Williton, Somerset, *pastel sketch. First sketch shows strength without delicacy. Tones are incorrect, but subject is clearly stated.*

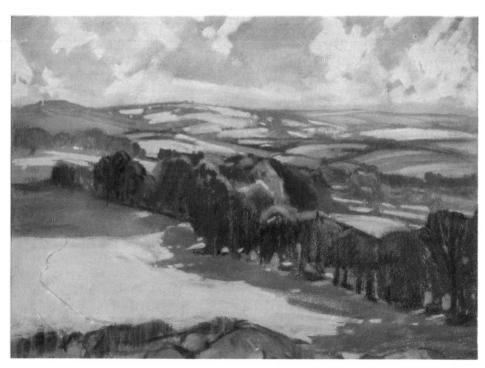

Plate XLVIII. The Brendon Hills from Williton, Somerset, *finished pastel painting. Clouds no longer assert themselves at expense of foreground; delicate color of hills places them at proper distance; trees and shadows show more interesting pattern.*

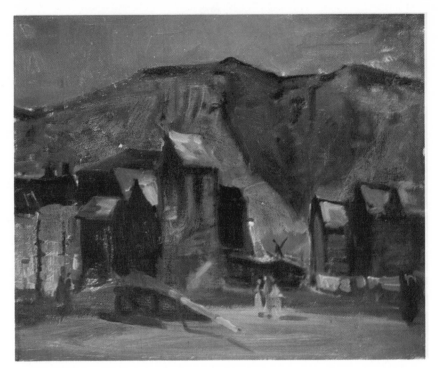

Plate XLIX. OLD NET HOUSES, HASTINGS, *oil sketch, was done with real excitement, no attempt to show rock strata. Colors are too strong, but sketch conveys power of subject.*

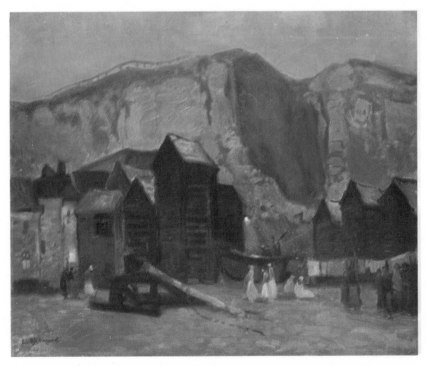

Plate L. OLD NET HOUSES, HASTINGS, *finished oil painting. Strong colors are painted out on cliffs behind houses; structural formation is more clearly expressed by warm grays, bluish shadows, obvious brush handling.*

Moods of Nature

Nature has many moods, some of which are of very short duration. It is difficult to respond to these moods unless the artist is quite alone and in a state of receptivity to outside influences. To be alone in a woodland area, where little sunlight can get through the dense foliage, suggests a totally different feeling from that produced if the same wood is occupied by a party of holiday trippers.

EXPRESSING MOOD Another curious feature as regards moods is that no two artists ever appear to receive the same message from nature, even if they are painting precisely the same subject. On this principle, supposing a thousand or so artists painted the same subject, and nature had a different message for each, no two pictures would be the same. Does not this open up boundless possibilities for landscape pictures displaying varying moods? It is noticeable that the majority of easily rendered sketches, if done with some measure of vitality and painted without any technical difficulties, convey the message nature had intended to transmit to the artist.

Presuming this to be true, how is it that in so many exhibitions and art galleries there is a similarity of expression in landscape pictures? It is possible that material environment and studio life have something to do with the loss of the real message. Selecting art committees, too, often play havoc by taking in only those pictures that show fine technique in the conventional sense of the word. Men in high positions in art have been known to exclaim, on viewing a picture, "What a splendidly painted picture that is!" Where, then, does the art come in? Where is nature's message as interpreted by the artist? Have landscape painters no power to arouse aesthetic feeling or some emotional sense in the mind of the spectator? Most decidedly they should have.

The moods of nature are without end, and should the student not find the mood of the moment, then he can superimpose his own mood in a landscape. It is comparatively easy for an artist to suggest sentiment in a

picture, provided that he has a wide knowledge of nature's forms and colors. Without this wide knowledge, it is not easy for any student to express a mood when using nature as the medium for expression.

TRANQUILITY Plates XXXVI, XXXVII, XXXVIII, and XXXIX are four pictures painted in watercolor on canvas-grained paper, with a little body color (opaque white) in places; considerable wiping out was done to obtain a luminous and liquid effect. Each of these pictures represents an obvious mood. There are far more subtle moods than these in nature, but for the sake of a clear understanding, the four illustrations are given as a beginning point for the greater moods to follow.

Plate XXXVI is entitled *Tranquility*. Tranquility in this illustration is obtained by the severe upright parallel lines of the vertical trees, rising at right angles to the flat ground below. The absence of flamboyant curves, or dark shadows opposed to brilliant highlights, supports the title of the picture. The horizon leaves plenty of room for the comparatively flat sky above. This is seen in Fig. 2, Chapter 3.

STORM The next example, Plate XXXVII is entitled *Storm*. This is always an interesting subject for artists. It is obvious, when sketching storm subjects, that the painter is rarely able to sit out of doors for any length of time without the chance of being deluged at any moment. All that the artist can do is to visualize the scene, and, while the excitement still lasts, to go back to the studio and render the impression of what was seen out of doors. This sort of impression of a scene is sometimes much more faithful than an attempt to imitate the impossible.

Notice in the colored illustration, how the taller trees on the left slant towards the right, and how the smaller trees bend in the same direction. The whole landscape is under the influence of a violent gale, moving from the left towards the right, and the illusion of wind is created by the more or less parallel direction of the trees and clouds.

MOONLIGHT AND EVENING Plate XXXVIII, entitled *Moonlight*, possesses the glamor of the night. It needs little explanation. So many moonlights have been painted before. Plate XXXIX is entitled *Evening*.

VIOLENCE IN NATURE Plate XL is a full page illustration of a Canadian waterfall. This represents another mood. As regards the design of the picture, the sky and distant mountains are kept low in tone so that the attention of the spectator can be focused on the subject—the waterfall. There is a certain amount of velocity in the movement of this water. The foam is too great to allow for any positive reflections.

The dark pine trees, particularly towards the central portion of the picture, through which the water is flowing, give an admirable illustration of contrast because of their vertical lines, suggesting rigid form when seen against the flexibility and softness of swiftly running water. The same idea applies also to the solid rocks. The lower rocks, being well splashed with spray from the waterfall, are light in tone, both in the highlights and in the shadows. The sunlight on the foreground reflects its brilliancy in the wet shadows.

The foundation colors in this picture are as follows.

Sky: warm gray interspaced with patches of yellow ochre and bluish purple.

Mountains: dark warm gray, bluish purple, terra verte mixed with a little yellow ochre.

Distant trees: permanent blue mixed with purplish gray.

Nearer trees: burnt umber mixed with a little ivory black, raw umber, permanent blue.

Rocks: burnt sienna, yellow ochre, purple (middle tint), silver gray (fairly dark in shade).

Water: yellow ochre, warm gray mixed with a little viridian, light reddish purple.

The mixing of any stated color with another must be done on the palette so that, when painted on canvas, the two colors will make one tint. These remarks apply to all the pictorial subjects in this book.

MAJESTY IN NATURE

Plate XLII is a picture entitled *Bow Falls, Banff, Canadian Rockies*. This picture represents a mood of its own. The trees were so dark and sinister in nature that the artist had, to a certain extent, to exaggerate the tones in the painting to convey the powerful effect felt in the lowering clouds, dark trees, and the light colored foam of the falls.

There are two stages shown in this picture. The first stage, Plate XLI, explains itself to a great extent. There is still some of the drawing left, as can be seen under the first wash of watercolor paint. This picture was painted in transparent watercolor on canvas grained paper, without any assistance from opaque color. In the final stage (Plate XLII) deep shadows were added, the trees darkened, and detail shown where necessary, while the whole of the sky and distant mountains were united through one flat wash of light yellowish gray.

In watercolor painting it is very important sometimes—in fact, nearly always so when there is no body color used—to wash a transparent light tint over portions of the colored ground work so as to unite and solidify the whole scheme involved in the painting.

The chief item of interest in the adjacent line composition is shown in the strength of several horizontal lines in the lower portion of the picture, contrasting with the jagged contours above.

The apex of each mountain touches the dotted curve from left to right. The line of the group of trees above the falls on the left, by being extended, continues upwards at a tangent to the group of trees on the right.

A MELANCHOLY MOOD

Plate XLIV is entitled *Barmouth Estuary*. This is a very difficult subject for an artist to paint. There is nothing in the natural subject to create a feeling of exhilaration. There is no strong sunlight, and the sky is nearly as dark as the distant hills.

In the first stage (Plate XLIII) the colors were painted in with fairly bright tints, and somewhat flat. Had the groundwork been a little darker in color, it would have made an easier surface on which to paint the final colors. This

subject has no sparkle and very little vitality, yet it is one of nature's own moods. Pictorially, it possesses little to attract the average spectator, merely depicting one of those drab, quiet, melancholy days which is usually followed by rain.

Its construction is explained in the adjacent diagram. Notice that the horizontal line of the sea is placed two-thirds of the distance up from the bottom line of the picture.

The coast lines on the left, in the middle and farther distance, connect (as shown by dotted lines) with the foreground construction.

Enough has been said in this chapter to suggest the possibility of obtaining plenty of variety in landscape pictures, should the artist be blessed with the gift of interpretation.

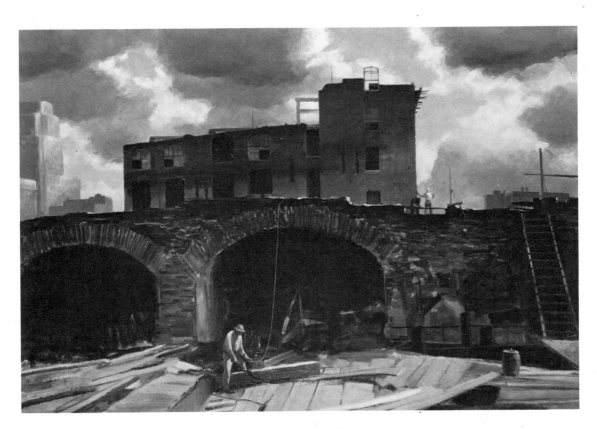

DEMOLITION by Harry Leith-Ross, oil.

When clouds move across the sky, partly obscuring the sun, partly allowing light to go through to the earth below, so-called cloud shadows are produced. Such shadows are often a convenient way for enlivening a landscape. In this painting, a cloud shadow falls partly across the face of the building which looms against the sky. Thus, part of the building is in shadow and part is illuminated. The sky, itself, is a lively pattern of dark clouds, with light breaking through, and the areas of dark and light are carefully placed to dramatize the building. As the receding boards in the foreground indicate, the horizon line is low; thus, the main elements of the picture are above eye level, which makes them even more imposing. (Courtesy Pennsylvania Academy of the Fine Arts, Philadelphia, Pennsylvania)

132

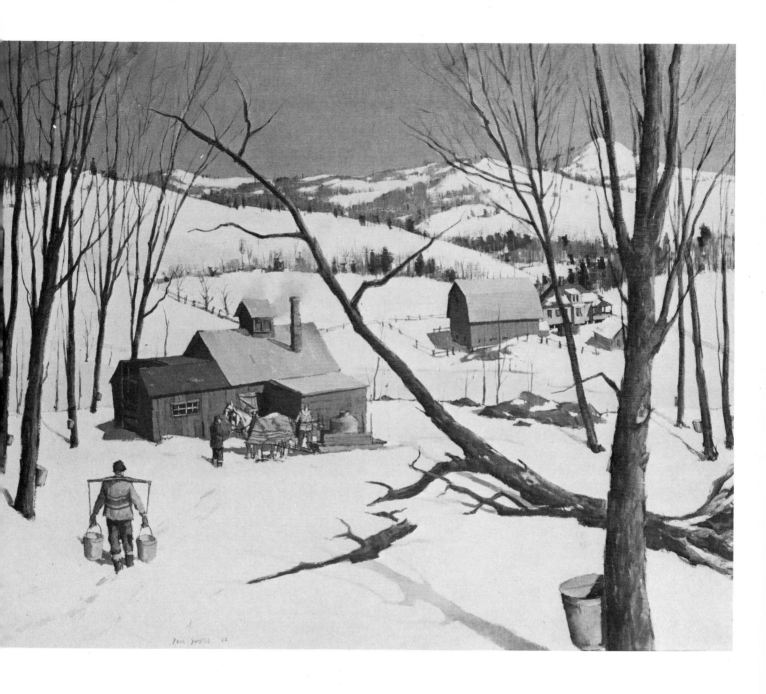

Maple Sugaring in Vermount by Paul Sample, oil.

*The artist has used the whiteness of the snow very much as he might use
the whiteness of the paper in a watercolor. The snow shapes are kept flat
and un-modeled, but are divided with great care into a variety of interesting
flat shapes by patches of foliage and the bare trunks of the trees. It is par-
ticularly interesting to see how the upright trees bend in slightly toward
the center of the picture and frame the central action; most important of
all is the fallen tree which cuts diagonally across the composition to center
the viewer's attention on the house and figures. Despite the strong, clear
light, there are few tree shadows; however, a single tree shadow points
diagonally inward from the foreground, leading to the center of interest.
(Photograph courtesy American Artist)*

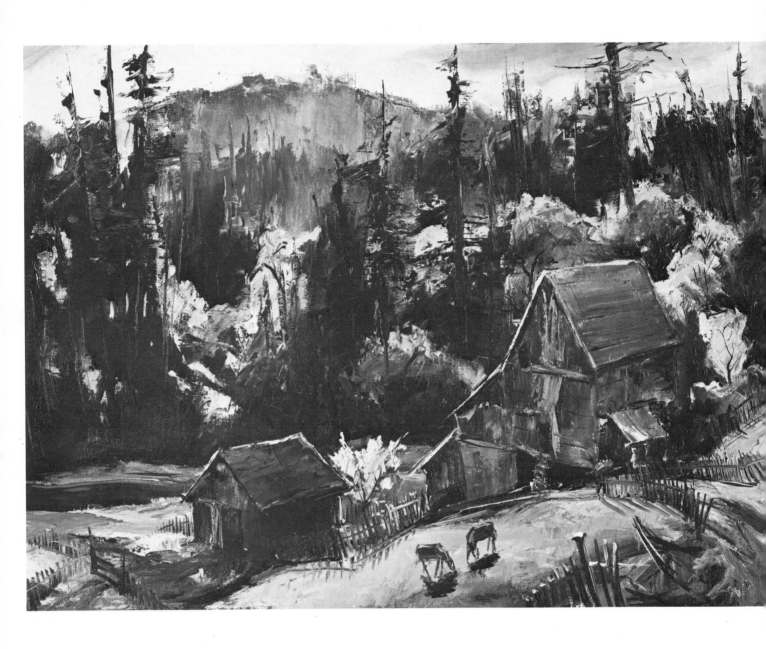

BREATHING SPACE by Joshua Meador, oil.

The artist's vigorous brushwork and the dynamic texture of the paint exude vitality. The paint is applied in a direct, spontaneous way, with very little attempt to blend tones or produce smooth textures. The roughness of the paint in the forest, for example, is calculated to express the tangle of trunks and foliage. In a different way, the direction and texture of the strokes express the quality of the wood of the buildings in the foreground. Notice, in particular, how thickly the paint is applied in the areas struck by sunlight; this is an old master rule of thumb—"paint thinly in the shadows and thickly in the light." (Photograph courtesy American Artist)

17

The Use of
Outdoor Sketches

Some people suffer from the idea that artists, if they cared to do so, could give away the secret as to how they manage to turn their sketches to good account when making indoor pictures. There is no secret; neither is there any recipe for this achievement. It is merely a matter of common sense and constructional ability in the studio.

WORKING IN THE STUDIO · The feeling of liberty which naturally arises in the mind of the artist when all the creature comforts of studio life are available, and all the trials and tribulations of outdoor sketching are done away with, for the moment, is a good augury for a successful and well balanced painting. Generally, one is more courageous when away from nature than when facing all that she has to say. Some of the finest things have been painted indoors as the result of knowledge accumulated through outdoor sketching. It is possible to evolve a passable looking picture indoors *without* a great deal of knowledge, but this is a poor comfort for the earnest student. If your sketches have good values and each sketch is backed up with pencil studies, there is every prospect of achieving something really worthwhile. The lack of logical tones in a sketch is a greater disaster than the lack of detail.

The artist, when painting the final picture in the studio from outdoor studies, has the privilege of leaving out noticeable mistakes as seen in the outdoor sketch or sketches. For instance, a sketch of quickly moving clouds, which has failed to suggest the feeling of movement, can be remedied in the studio partly through memory and partly through common sense based on theoretical construction. Another sketch of a scene may be lacking in contrast. It is not a difficult matter, in the sanctuary of a studio, to brighten the highlights and deepen the shadows without losing the general harmony of the picture. There are no restrictions for the artist as regards any alterations in the finished picture. I have not only altered a picture in the studio, but have sometimes painted four of the same subject, and selected the best one for exhibition.

Avoid mannerisms in painting. Mannerisms are usually caused through too much indoor painting: the artist adopts an arbitrary style of technique and uses it to express all moods of nature. The handling of pigment in a picture should help the subject. Every landscape demands just that style of technique which, without any ostentation, is best suited for the picture.

After some six months' outdoor sketching, one can become rather weary of the physical and mental work involved, and the reaction of going back to studio life arouses all the feelings of freshness and virility. Then, at the end of another six months or less in the studio, one becomes tired and jaded through lack of the fresh outdoor life, and it becomes advisable to go back to nature once more so as to regain the lost vitality.

SKETCH AND FINISHED PICTURE IN OILS Plate XLV represents the sketch of a subject entitled *The Watchet Coast, Somerset*. Plate XLVI is the finished picture. The sky in the finished picture has lost that cold, grayish blue, which is seen in the sketch above. Dealing with the finished picture, notice that the rocks in the immediate foreground, resting on the shore, show more form and better drawing. The contour of the cliffs, commencing from the top left side and continuing downwards towards the central portion of the picture, displays fairly accurate drawing, while the slighter tinges of red on the edges send them back into proper tone relation. The strong light resting on the face of the cliff, coming more or less vertically downwards, has a suggestion of gray color which is missing in the sketch, thus helping to make the light appear to be in the surface of the cliff, instead of being in front of the cliff.

In an oil sketch of this sort, it is splendid practice and a tonic for the mind to paint vigorously with strong brushmarks. Mistakes are welcome—they suggest something. What does it matter if the paint is put on too thick or too thin, or if the rock is lacking in structural drawing in your sketch? It is, of course, preferable to achieve everything that is desirable right away, but that is almost impossible and the next best thing is to get as much workmanlike decision as time will allow, and a strong sense of tone, so that there is some chance of getting useful material that can be of help in the studio.

SKETCH AND FINISHED PICTURE IN PASTEL Plate XLVII is another sketch, with the finished picture in Plate XLVIII, entitled *The Brendon Hills, from Williton, Somerset*. The sketch shows strength without delicacy. Tones are incorrect, but subject clearly stated.

The finished picture below—done in pastel also—is carried almost too far as regards finish. Here it is noticeable that the clouds are no longer trying to assert themselves at the expense of the foreground. Their lighter tints keep them in their proper tone relations to the distance, middle distance, and foreground. The drawing of the distant hills shows more scholarly knowledge. The hills that are farthest away in the distance (on the right) have light touches of bluish green and purple, and are so delicate in tone that they help to create a feeling of being a very long distance from the spectator. The drawing of the trees in the central portion of the picture shows a more interesting pattern of light and shadow. The rocky formation at the foot of the picture is constructed more logically. The heavy weight of the shadows thrown by the trees on the adjoining field is illuminated with reflected light, and the drawing is more carefully rendered.

Plate XLIX is another sketch, with the finished picture (Plate L), entitled *Old Net Houses, Hastings*. The sketch was done with real excitement, with no attempt at showing the strata on the rocks behind the old net houses. The blue is too strong and the purple is too strong, but what a feeling of consolation the artist had in knowing that here was something on which he could build the real thing!

In the finished picture (Plate L), it is noticeable that the strong reddish purple is painted out on the cliff behind, with the structural formation more clearly expressed by means of warm grays and bluish shadows with obvious brush handling. The drawing of the old net houses is more carefully handled, and the tonality of the foreground is more accurate with far less purple.

These pages, showing sketches and finished pictures, should convey to the student that the only thing that really matters is decisive statement in color and tone, whether it be oil, watercolor, or pastel.

The dark tones of the tall nethouses help, through contrast in the depth of color, to keep the cliffs well in the background. The figures in the foreground are mere color expressions, without positive drawing. For evening or night effects, suggestion of form is more important than definite statement.

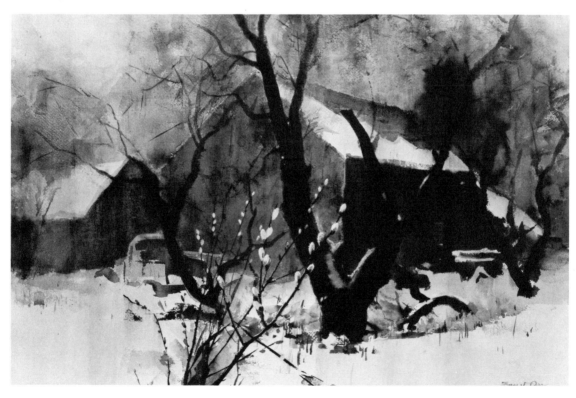

CHANGING SEASON by Forrest Orr, watercolor.

The essence of this landscape is in the artist's control of values. The plant and cluster of trees in the foreground are rendered in strong darks which bring them close to the viewer. The buildings are painted in more subtle tones, which drop back into the distance. And beyond the buildings are a few patches of delicate tone that suggest remote forest and sky. The only really crisp detail is in the immediate foreground, where the branches and buds are painted with extreme clarity. The rest of the painting is surprisingly rough and lacking in detail. (Photograph courtesy American Artist)

VAL DE GRACE by Ogden M. Pleissner, oil 24″ x 36″.

In this cityscape, the horizon line is very low in the picture and the viewer feels that he is standing at street level with the figures in the foreground. Because of the low horizon line, the buildings loom high up in the sky and the street is seen in extreme perspective, with the buildings receding very rapidly into the distance toward a vanishing point which is somewhere at the very end of the street. This use of perspective lends great mass and strength to the forms of the buildings. It is also interesting to note that the strongest light in the picture is not on the buildings themselves, but beyond them in the sky, thus throwing their forms into silhouette. (Photograph courtesy American Artist)

Various Materials

In the last chapter of this book, it may appropriate to suggest a few practical things relating to materials.

PASTEL MATERIALS

In pastel sketching, it is not necessary to carry an easel or anything of a heavy nature. Take an ordinary sketching stool, a sturdy piece of hard board about 19″ x 25″, and half a dozen pieces of colored paper, about 18″ x 24″ so as to leave half an inch margin when clipped to the board.

The paper should be fairly smooth in texture and not too bright in color. Avoid rough paper, sandpaper, and felt surfaced paper. Gray, brown, and warm green are better than purple or bright yellow. The latter two are liable to fade quickly, whereas the former three papers have more permanent qualities. A box of handmade pastels, with some 70 to 100 varying tints— including a lavish number of sticks of yellow ochre, gray, deep brown, burnt sienna, black and blue, with a few sticks of red, deep violet, green, white, etc.—should also be included, as without some of the above there can be no foundation tints, which are so essential for laying in the initial stage of a sketch. Pastel boxes, as sold in art supply shops, have plenty of pleasing colors—sometimes too many for practical use.

Ordinary spring clips (to hold the paper to the board) should complete the outfit.

When the pastel sketch is finished, take the clips off, and (with care) place the sketch underneath the other pieces of paper, immediately clipping the papers once more along the edges of the board. When the pastel sketch is packed underneath the other papers, see that it has no chance of slipping. When traveling, the artist should see that all pastel sketches are bound securely together, either with tightly drawn string or with clips.

WATERCOLOR MATERIALS

In watercolor sketching, a small easel is sometimes used. Anything that is simple should lead to better work. Personally, I never use an easel for water-color sketching, since I keep the paper almost horizontal, but I find it useful

to have a miniature stool (in addition to the ordinary sketching stool) on which to place a large jar of water, together with the watercolor sketchbox. I hold the sketch (which rests on the knees) in the left hand, paint with the right hand, and any water that runs off the sketch falls on to an old cloth which is placed below the painting. I can think of nothing simpler than this method.

It is interesting, in watercolor sketching, to experiment with various papers. Well known papers include D'Arches, Whatman (now no longer made, but still sold here and there), Fabriano, Arnold, Crisbrook, R.W.S., and the popular Japanese papers. There are, of course, various lightly tinted papers with a fairly smooth surface, useful for both transparent washes or for body color.

OIL PAINTING EQUIPMENT

For oil painting, it is necessary to have something sturdy and strong in the way of an easel, and to stand up to the work. An occasional step backwards will enable the artist to compare the tones. There are on the market simple easels for outdoor oil sketching, and any good artists' supply store invariably has several selections. An oil sketch box, fitted with brass telescopic legs, may appeal to some students. Its chief virtue is that the box can always be kept in a horizontal position, even on the sloping side of a hill, by adjusting the length of the telescopic legs. Also it is steady when opposed to powerful winds out of doors. The student will soon find out which appeals to him as regards an oil sketching outfit.

SUGGESTIONS ABOUT COLOR

In oil sketching, it is nearly always best to paint low in tone with thin color, using plenty of oil medium, such as linseed oil and turpentine, with a little copal varnish, and finally place the solid lighter colors over the darker tints. It is very difficult to paint dark oil colors on top of light tints. Precisely the same remarks apply to pastel painting, and also to body color when used with watercolor.

In pure transparent watercolor painting, the opposite method is adopted to that employed in oil and pastel painting. The first stage should be lightly tinted, and in the final stage the deepest colors should be used.

The colors used for the paintings as seen in the various reproductions throughout this book were selected from the following list.

COLORS FOR OIL PAINTING

Zinc white
Lemon yellow (zinc yellow, cadmium yellow light)
Chrome yellow and orange
Yellow ochre
Vermilion
Light red
Permanent crimson (alizarin crimson)
Cobalt green
Viridian

COLORS FOR WATERCOLOR PAINTING

Tempera white (body color)
Chinese white (body color)
Lemon yellow (gamboge, cadmium yellow light)
Chrome yellow and orange
Yellow ochre
Vermilion
Light red
Permanent crimson (alizarin crimson)
Viridian
Deep Hooker's green

Terre verte
Permanent blue (phthalocyanine blue)
Cobalt blue
Cerulean blue
Raw sienna
Burnt sienna
Burnt umber
Ivory black

Permanent blue (phthalocyanine blue)
Deep ultramarine blue
Cerulean blue
Burnt sienna
Ivory black

SELECTING PASTEL COLORS Pastels (and only soft handmade sticks are of any value) can be purchased in boxes ready for use, containing many colors of varying tints, nearly all of which are permanent. Carmine should be avoided, as it fades quite early.

The best way, when buying pastels, is to make a careful selection of some seventy tints, several of which, such as white, yellow ochre, gray, burnt sienna, and black, can be duplicated, since these colors are in constant use during the making of a sketch. Emerald green and the various shades of Hooker's green are invaluable, since they respond easily when in use. Certain other bright greens are known to be hard and gritty in quality. Good russet and olive greens are on the market, and there is an astonishing number of shades of red, orange, purple, brilliant yellow, etc.; but caution should be exercised when selecting the brighter tints, as they tend to cheapen the effect when used in a sketch.

It is excellent practice in this medium to try to get several tints with one color. Use light yellow ochre on dark gray paper. Break off a small piece of light yellow ochre, about an inch long, and use it by pressing lightly on the dark paper. The result will be fairly dark. Press again, only with more firmness, and the result will be a lighter tint. If heavier pressure be exercised, the result will be quite light, and about the same color as the original stick of pastel.

Index